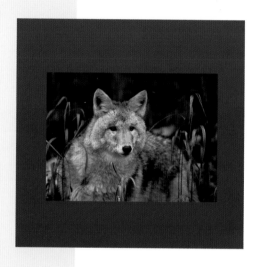

Captivating Wildlife
Images from America's top ten emerging wildlife photographers
$29.95 USA

Publisher:
Olympic Mountain School Press
P.O. Box 1114
Gig Harbor, WA 98335
1-253-858-4448
www.mountainschoolpress.com

ISBN: 0-9761878-3-3
Library of Congress Control Number: 2005931302

Printed in China

Other books from Olympic Mountain School Press

88 Secrets to Selling & Publishing Your Photography
88 Secrets to Photoshop for Photographers
88 Secrets to Wildlife Photography

Captivating Wildlife

Images from America's top ten emerging wildlife photographers

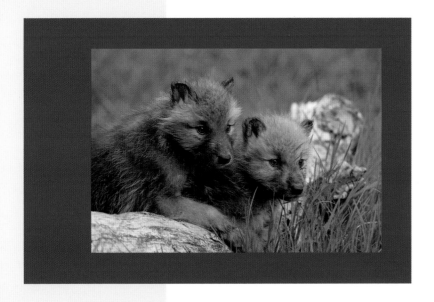

text and images by

SCOTT BOURNE
& DAVID MIDDLETON

master nature & wildlife photographers

Additional images by:

Richard Badger
Carlene Cunningham
Jim Cunningham
Victoria Dye
Debra Feinman
Donald Knight
Kimi Lucas
Brad McPhee
Patrick Reeves
Carolyn E. Wright
emerging wildlife photographers

Olympic Mountain School Press - Gig Harbor, Washington

You can order prints from this book

Visit www.captivatingwildlife.com to purchase any of the images in this book. Pricing, size and availability are determined by the photographers.

These images are also available for commercial use. For licening information, contact the photographers directly or through www.captivatingwildlife.com.

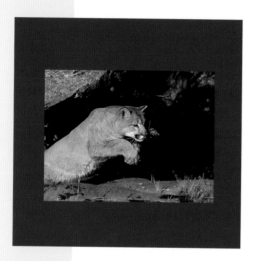

Dedication

This book is dedicated to our friends and family and to the owners and staff at the Triple "D" Game Farm, in Kalispell, Mont.

Scott Bourne & David Middleton

Acknowledgments

Thanks to Jay Deist at the Triple "D" Game Farm for providing access to all of the animals photographed for this book. See the story about Jay in the back of this book or visit the Triple "D" web site at www.tripledgamefarm.com.

Thanks to NANPA president Darrell Gulin for his kind words about the book.

Thanks to Denise Knudson for her always inspiring design work.

Thanks to Carolyn E. Wright for providing legal services to this project. See Carolyn's web site at www.photoattorney.com.

Thanks to Jana Bourne for her assistance in editing and preparing the manuscript and for her assistance with the publication of Captivating Wildlife.

Thanks to Robin Bartlett for help with early edits and for his expertise and advice on all things related to book publishing. See Robin's web site at www.robinbartlett.com.

Thanks to Rod Barbee for scanning some of the images that went into this book.

Thanks to America's top ten emerging wildlife photographers:

Richard Badger
Carlene Cunningham
Jim Cunningham
Victoria Dye
Debra Feinman
Donald Knight
Kimi Lucas
Brad McPhee
Patrick Reeves
Carolyn E. Wright

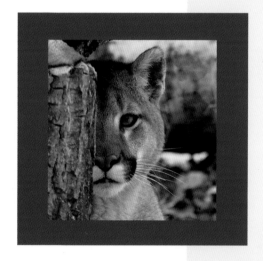

DAVID MIDDLETON

David Middleton is an internationally recognized nature and wildlife photographer. He is considered to be one of the finest visual environmental interpreters and teachers of photography in America.

A kid who always had camera in hand, his career started in the mid 1970s as a leader of natural history trips to see whales, exotic birds and national parks. He then moved on to leading international trips to South America and to Canada in search of such things as tropical rain forests, giant tortoises and polar bears.

Since then, he has earned his living as a professional photographer and naturalist by writing, teaching and sharing his knowledge of the natural world.

David has led more than 100 natural history tours across North and South America from the High Arctic to the Antarctic and has taught more than 150 photography workshops. He teaches more than a dozen photography and creativity workshops to serious amateurs and aspiring pros and critiques 10,000 of his students' images annually. David has taught all ages of students from Montessori pre-school, elementary school, middle school, high school, and college to graduate school, adult education and Elder-hostel.

David is currently working on five new books. He is represented by two international stock agencies, a web gallery and by his own company, David Middleton Photography.

SCOTT BOURNE

Scott Bourne's photography has received more than 100 national and international awards. He is known for his use of color, shape and form in photography. He is also a pioneer in the digital imaging field.

While his current passion is wildlife photography, Scott's photographic career started in the early 1970s as a stringer covering motor sports for Associated Press in Indianapolis. Since then, he has shot commercial, portrait, wedding, magazine and fine art assignments. Scott's photos have appeared across the United States in books, magazines, calendars, art galleries and newspapers.

Scott regularly teaches on a variety of photo and media-related subjects. He has appeared on national television and radio shows, has written columns for several national magazines, and led photo workshops for more than a dozen different companies or schools. In his spare time, Scott publishes Photofocus Magazine, one of the most popular photography e-zines on the Web.

Scott has written four photography books and is working on three more. In addition to his photographic assignment work, Scott is the executive director of the Olympic Mountain School of Photography and publisher of *Photofocus Magazine.*

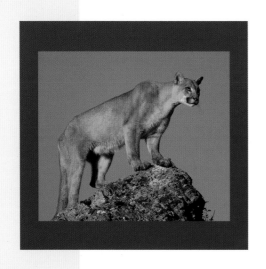

A

nimals are such agreeable friends - they ask no questions, they pass no criticisms.

George Elliot

ABOUT THIS PROJECT

This book is the result of a nationwide contest sponsored by Olympic Mountain School Press. Hundreds of photographers from around the United States submitted images for consideration. Professional photographers David Middleton and Scott Bourne viewed thousands of photographs before selecting the ten emerging artists represented in *Captivating Wildlife.*

The photographers who made these images exercised great skill and went to great expense to make these pictures. They have proven themselves and this book is a celebration of their skill.

We hope you appreciate the dedication of the photographers who made these images so that everyone could behold how truly captivating wildlife can be.

The Editors

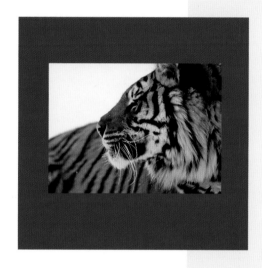

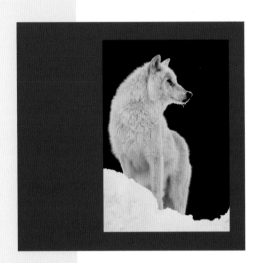

Introduction by Scott Bourne

What's different about the images in this book? You may have noticed that they are sharper than most wildlife images. You may have noticed that the pictures were all made in beautiful, natural settings. Perhaps the sweet light that floods each photograph caught your eye. Or maybe it was the fact that each specimen was perfect.

There's a reason for this perfection. All these animals were photographed under controlled conditions at the Triple "D" Game Farm in Kalispell, Mont., or on Triple "D"- sponsored outings in California and Utah.

This doesn't mean these animals are tame or trained. In fact, they retain most of the same characteristics of their non-captive brothers and sisters. Their genetics and behaviors are the same.

But because the animals – who are not domesticated – respond to a handler, we are able to make these stunning photographs. Most of the images that appear in this book would simply be impossible to make outside of controlled conditions. And even though we worked with expert handlers, we're not at a zoo. At Triple D, we photograph the animals in natural settings. We do not photograph the animals in cages and only occasionally do we work behind fences. And when we do use fences, they are not designed to keep the animals in. They are devices that act as protection for the animals.

The subjects in these photographs were not "trained" to pose for photo shoots. We wanted to photograph the animals in their natural habitats. So we had to bide our time, select our backgrounds, wait for the light and photograph the animals as they moved from place to place, sometimes mixing skill and luck to get the perfect shot.

In 30 years, no photographer has been hurt at Triple D because the owners, Jay and Kim Deist, make safety their top priority. That said, there is a risk to photographing any animal, wild or captive, shot under controlled or uncontrolled conditions. All of the photographers

participating here gladly took that risk and undertook significant financial expense to make these images. And the reason for that is simple. The images are the reward. In addition to the feeling of accomplishment we get when we make a superb image, photographers who shoot at Triple "D" have the satisfaction of knowing the images they make will help others appreciate the importance of protecting and respecting wildlife.

There's also the plain and simple thrill of being so close to nature in ways that most people will never experience. Imagine having an opportunity to see a mountain lion nurture her cub or watch a wolf devour its prey in its natural habitat. The pictures are really just a bonus. As photographers, we are awed by the beauty and grandeur that inhabit these creatures. We hope you will be too.

In addition to the images that David and I share with you in this book, we have selected photos from ten emerging professional wildlife photographers. We hope you enjoy the images and the opportunity to meet some of the rising talent in the world of wildlife photography. They are highly skilled photographers who have the passion of true professionals and deserve to have their work published right alongside the best of the best.

Gig Harbor, Washington - July 2005

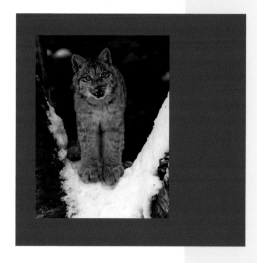

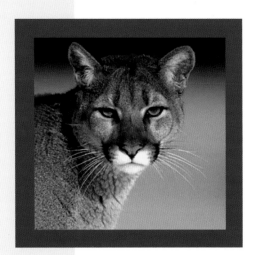

Introduction by David Middleton

Early in my photographic career I realized that photography was all about capturing light. Gone were the seduction of the subject and the grandeur of the scene as motivators for my picture taking. My students have heard me say this a thousand times: dull light equals a dull picture.

Soon, more revelations bubbled to the surface. The first was that the natural world was more than just grand landscapes and beautiful details. Nature actually has a heartbeat, and if I was going to call myself a nature photographer, I needed wildlife photos. My second great revelation was that wanting pictures of wildlife and actually shooting pictures of wildlife are two different things.

I thought I had everything I needed to shoot great wildlife pictures: long lenses, a knowledge of natural history, and plenty of time to find wildlife subjects. This led to a lot of wandering around the country shooting very mediocre pictures of animals that were too far away.

This led to another revelation: wildlife photography is hard. Not only do you need long lenses, some knowledge, lots of time, and great light, you also need the most important thing: opportunity. Intentions and equipment are wonderful but without the proper opportunity there's no picture.

Then my photography life changed. It was the mid 1980s, and I took my first trip to the Triple "D" Game Farm in Kalispell, Mont. In a five-day trip, I photographed mountain lions and bobcats, baby raccoons, lynx and even bears. With lenses and light and now – at last – opportunity, I had everything I needed to get spectacular photographs.

It was time for my next revelation. People often think that it must be easy to get the perfect shot with the animals of Triple "D" strolling around right in front of you. They would be wrong. Despite the apparent ease of the photography at Triple "D", it is almost impossible to get a perfect shot.

The animals at Triple "D" are not tame, highly trained animals. They are not pets trained to perform on command. I think of the animals of Triple D as surrogates for truly wild animals. Better to photograph the well cared for animals at Triple D than to harass wild animals that are already harassed enough.

The animals of Triple "D" are more wild than they are trained. Furthermore they are not parading around right in front of you. Most of the time, they are going just about where they want to in a very large compound. And if you want to get any pictures, you had better follow along after them. That is why tripods have legs.

And then my final revelation struck. Even when everything is going well, and you think you are getting really great shots, there will actually be just a moment or two when the photography is perfect. There will be lots of nice opportunities but only a few times in a session when the animal's position, pose, attitude and expression are all aligned with great light, perfect backgrounds and optimal photography conditions.

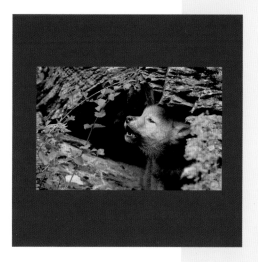

Wildlife photography is about capturing the perfect moment. Moments don't last long. You often have only a second or two to get the shot. In that second you have to compose, focus and press the shutter. If the animal's position and expression change or if the light shifts, or you miss focus, cut off the animal's legs, tail or nose, or if you just happen to blink, the shot will be gone forever.

This book is a celebration of perfect moments and the dedicated photographers who persevered to capture these moments. Feel free to revel in the magnificence and beauty of the animals in this book. And feel free to be amazed by these talented photographers.

Danby, Vermont - July 2005

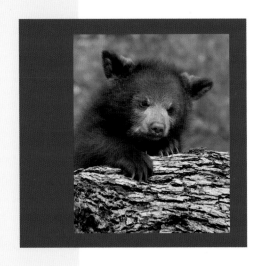

Compassion for animals is intimately connected with goodness of character; and it may be confidently asserted that he who is cruel to animals cannot be a good man.

Arthur Schopenhauer

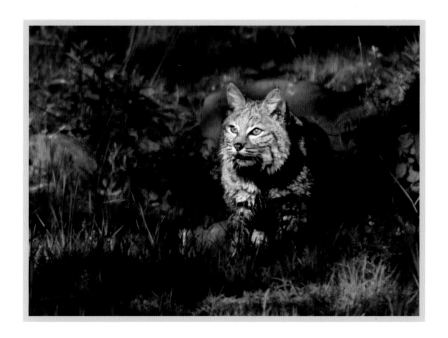

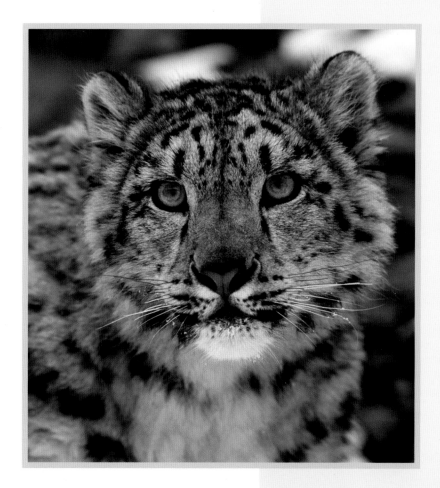

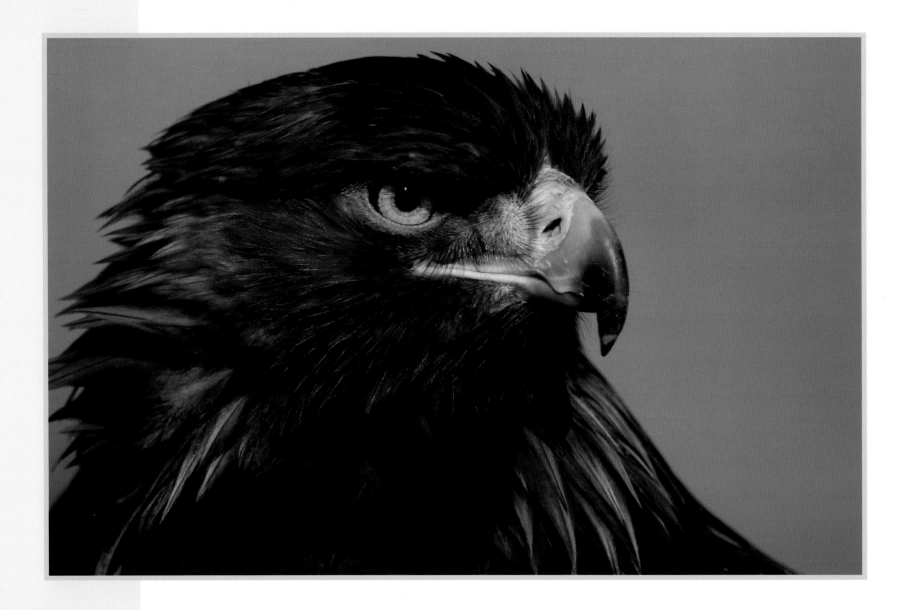

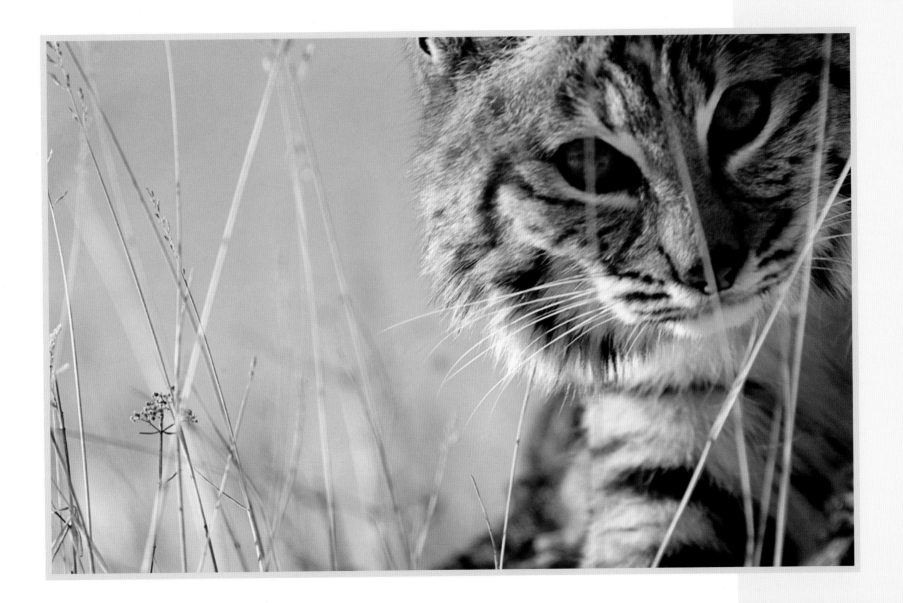

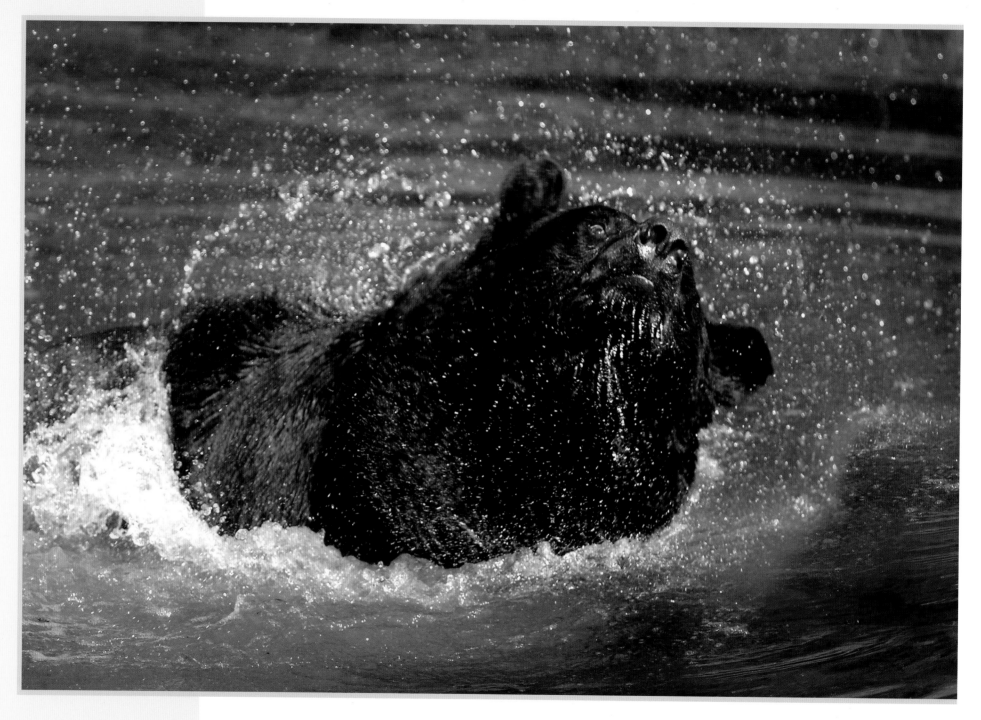

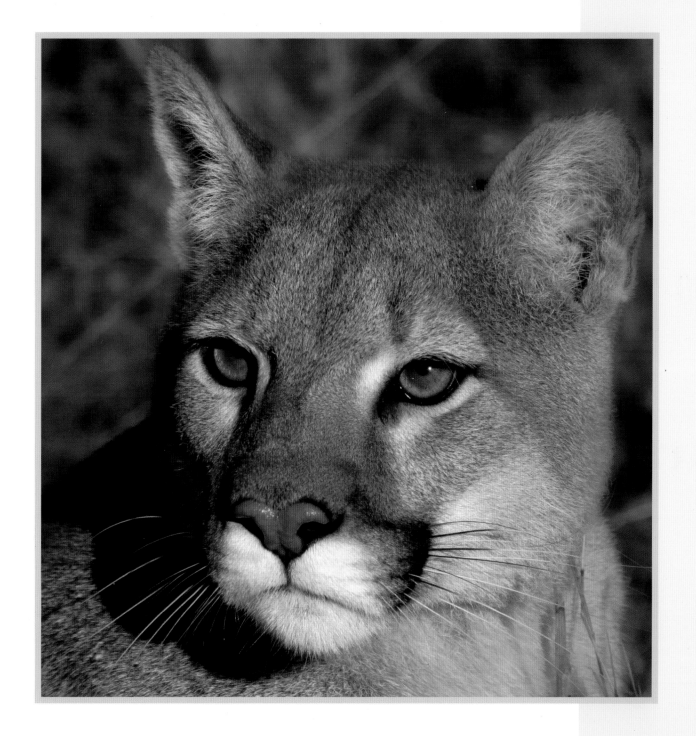

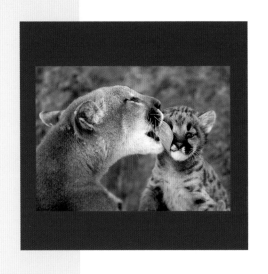

A

ll animals except man know that the ultimate of life is to enjoy it.

Samuel Butler

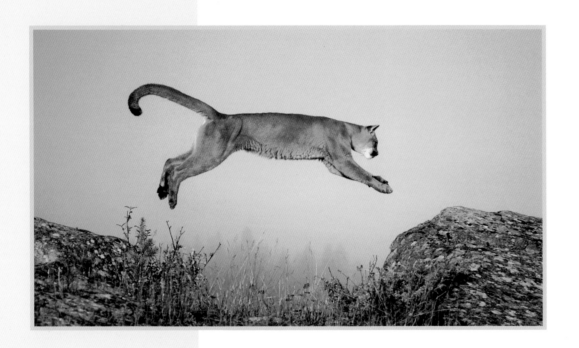

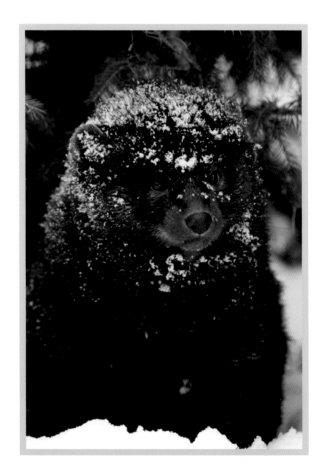

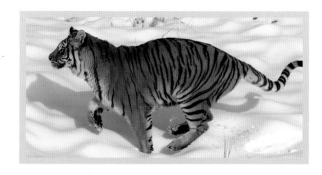

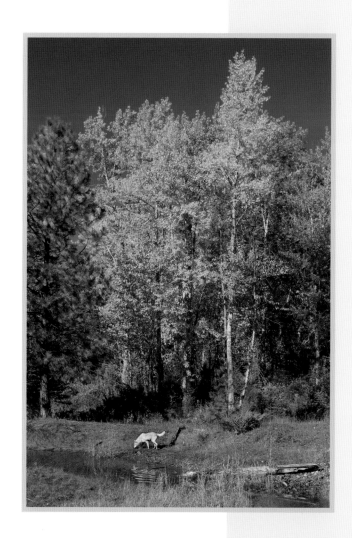

RICHARD BADGER

Richard's passion for nature photography began as a young man in the 1960s when he worked summers in the Olympic National Park. He used an old hand-me-down camera to make photographs of the park's landscape. Although he maintained an interest in photography, he became a veterinarian and it wasn't until 2002 that Richard began his photographic career in earnest.

Richard studied photography and attended classes and workshops focusing on nature and wildlife as the two primary subjects.

In 2004, after 31 years of private veterinary practice, Richard retired to concentrate on his photography.

Richard's photographic goals are simple. He strives to document moments that define the essence of an animal's world and show them to be sentient creatures with the same range of emotions often only attributed to humans.

Richard has a keen interest in environmental issues and he has donated some of his images to aid wildlife conservation. His work is on display throughout the Northwest.

CARLENE CUNNINGHAM

Carlene Cunningham raised a family of three children while working full time for 31 years at the U.S. Postal Service. After retiring, she decided to pursue photography.

Carlene and her husband Jim have traveled the world in search of the perfect wildlife image.

Carlene is a member of the Merced Camera Club, the San Joaquin Council of Camera Clubs and the Gold Rush Chapter. Carlene's photos have won in the SJVCCC Nature Division for several years. She candidly reports that she enjoys beating her husband and other competitors.

Carlene has studied with George Lepp, John Shaw, David Middleton, Galen Rowell, Lisle Dennis, Nevada Weir and Ernie Braun.

She enjoys the challenge of capturing wildlife in their natural surroundings.

Carlene currently resides on her family's cattle ranch on the eastern side of California's San Joaquin Valley near the small town of Le Grand.

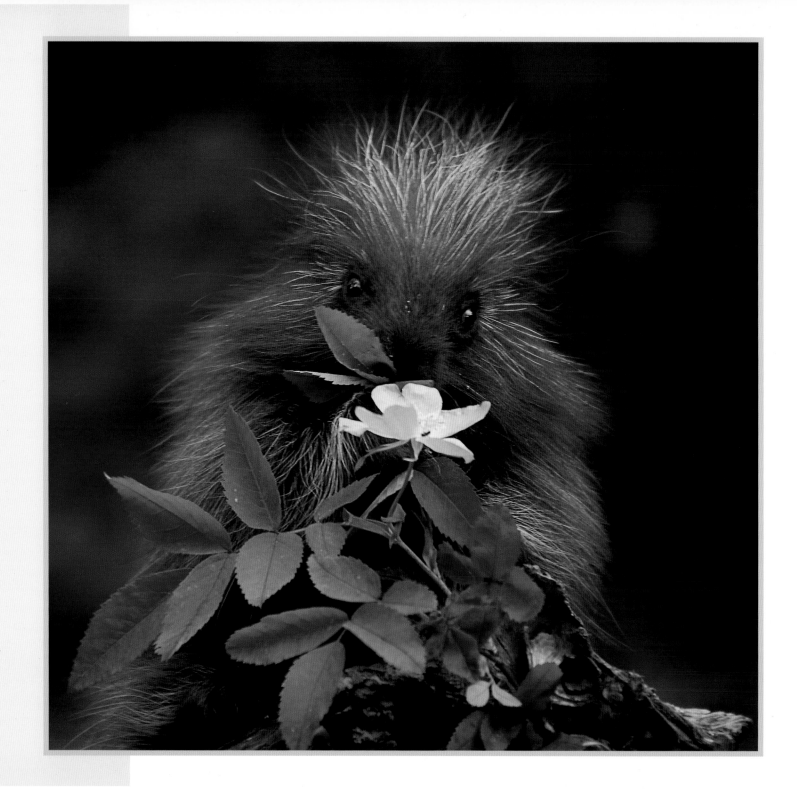

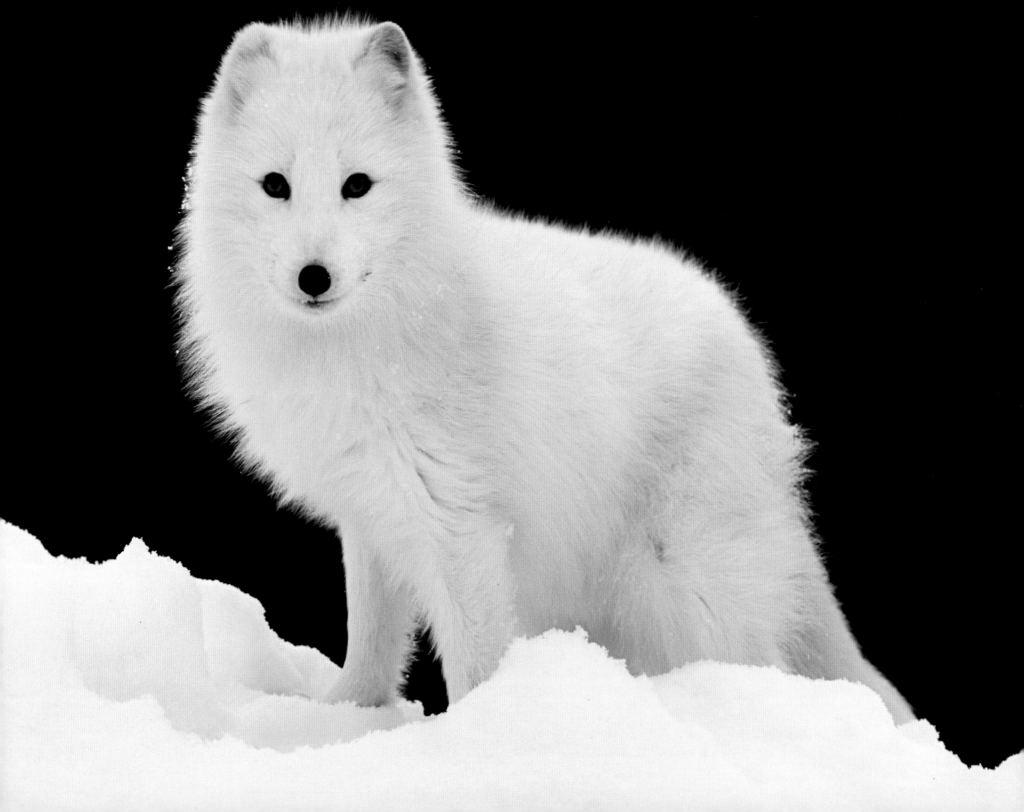

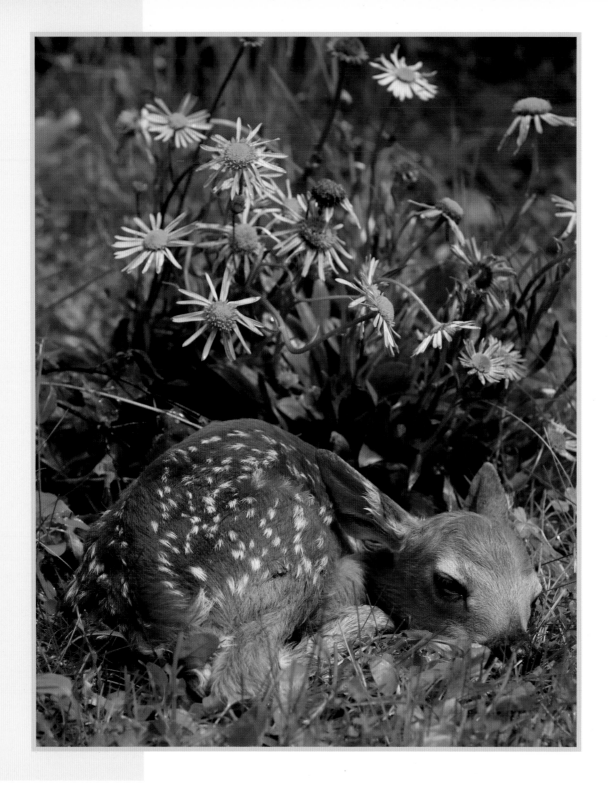
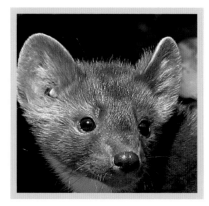

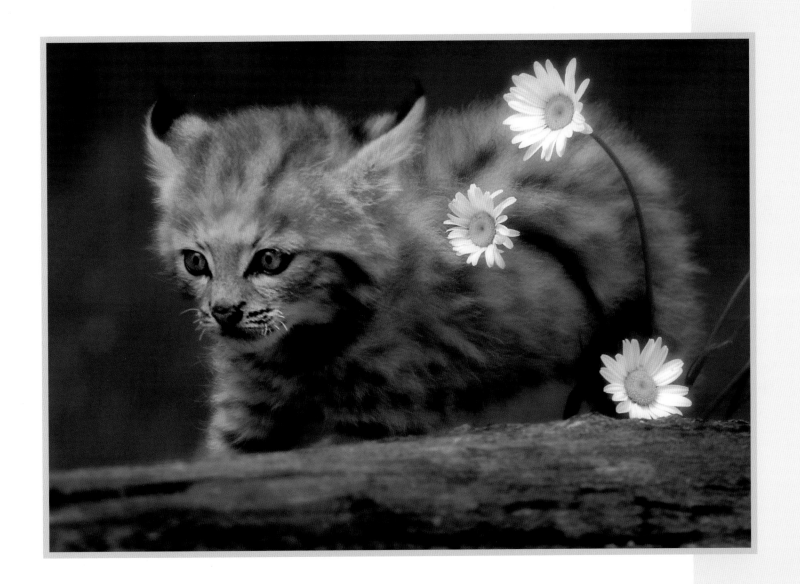

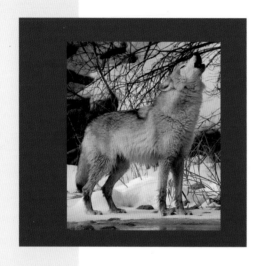

T he greatness of a nation and its moral progress can be judged by the way its animals are treated.

Mahatma Gandhi

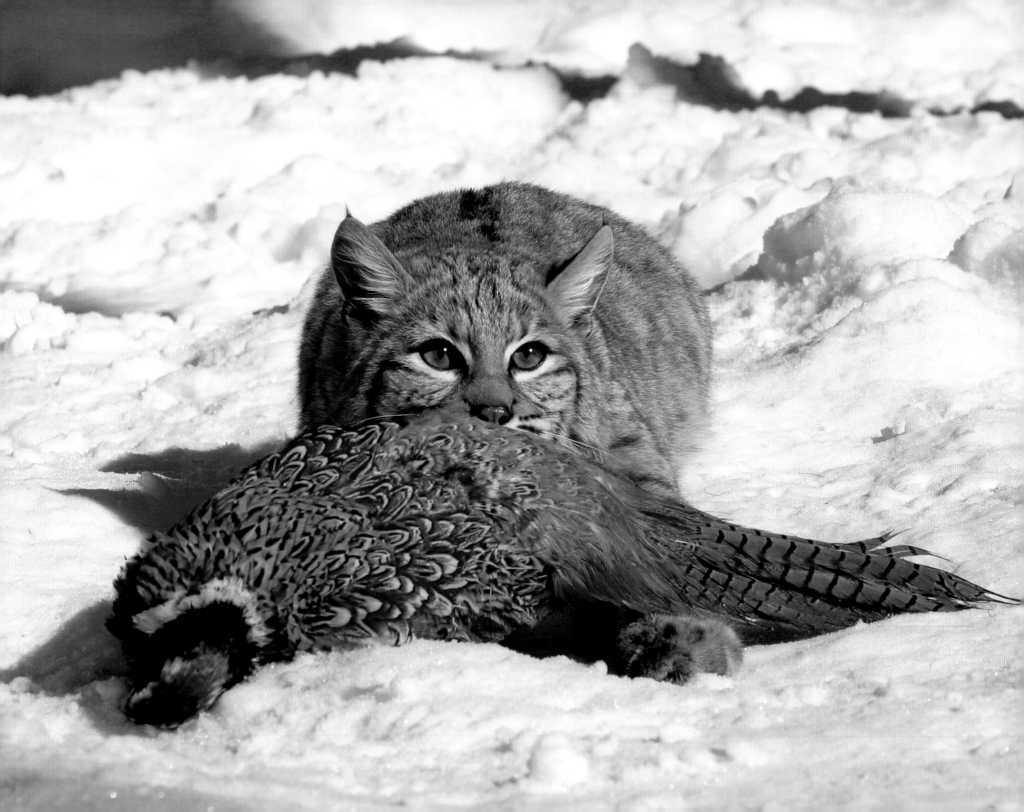

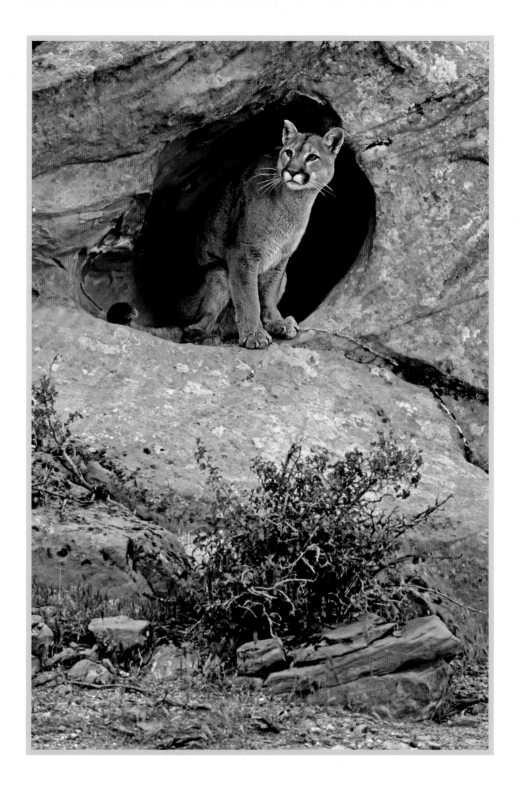
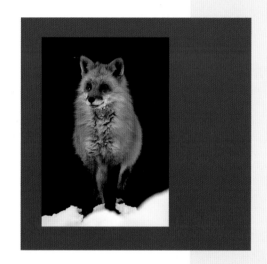

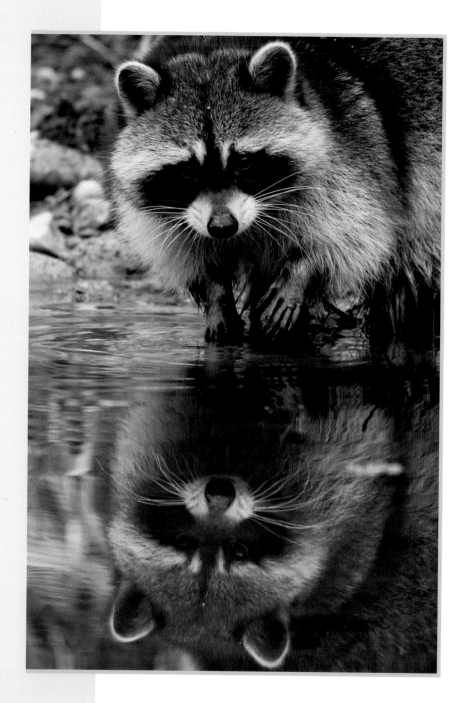

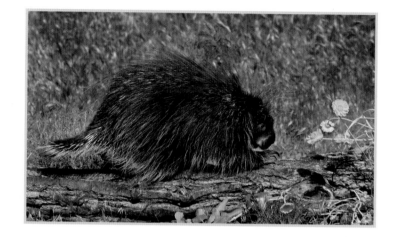

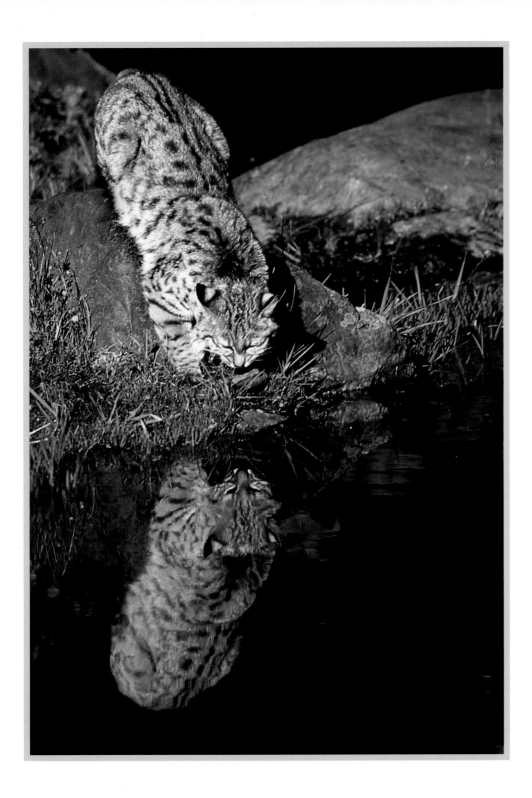

JIM CUNNINGHAM

Jim Cunningham is a fourth generation cattle rancher and owner of one of the oldest ranches in California, established in 1851. He has a long-standing interest in photography and an appreciation for the natural landscape and its inhabitants. His main photographic interest is wildlife. He credits his understanding of animal behavior with helping him make compelling nature images.

Jim and his wife Carlene have traveled to several unique locations, including many areas in Alaska, Canada and Spitsbergen, Norway. He also enjoys exploring the rugged country of the Southwest and spent many years as a "swamper" for Grand Canyon Expeditions leading raft trips on the Grand Canyon.

Jim's photography has appeared in many publications and is currently on display at the California State Capital and local office of California State Assemblywoman Barbara Matthews. One of his images, the "Golden Bobcat," is the mascot for the University of California in Merced.

Jim judges photography for many local camera clubs, fairs and other photographic competitions.

VICTORIA DYE

Victoria Dye is an award-winning photographer from Charlottesville, Va. Her photography career grew from her love of animals. She is primarily self taught and has augmented her training with classes and workshops at the Rocky Mountain School of Photography and the Olympic Mountain School of Photography.

Victoria has always focused her camera on nature and wildlife subjects. Victoria graduated from veterinary school 10 years ago and her love of animals led her to spend the past two years concentrating on wildlife photography.

Victoria's other passion is teaching. She teaches digital photography classes and speaks to various community groups in her area.

Victoria's work is featured in a Richmond, Va., gallery, and she has displayed work at various galleries and gift shops around the state. She is currently a member of the National Association of Nature Photographers, The Virginia Society for the Photographic Arts, The Ivy Creek Foundation, and the Staunton Augusta Art Center.

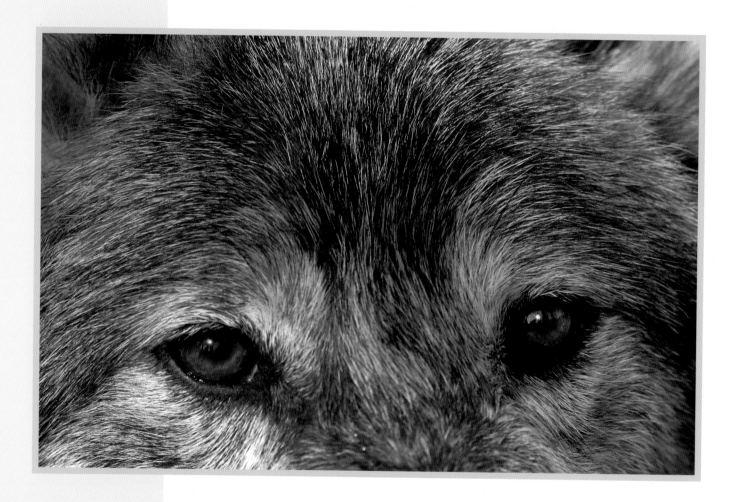

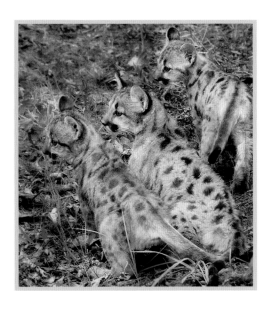

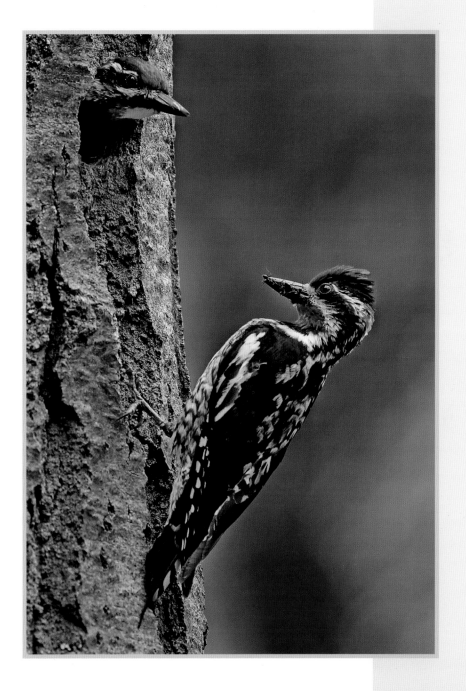

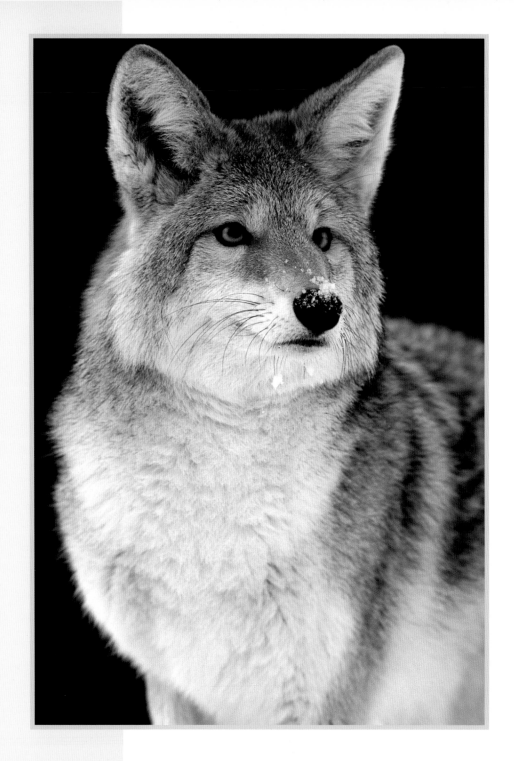

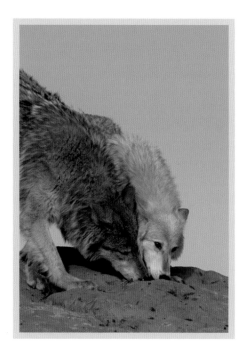

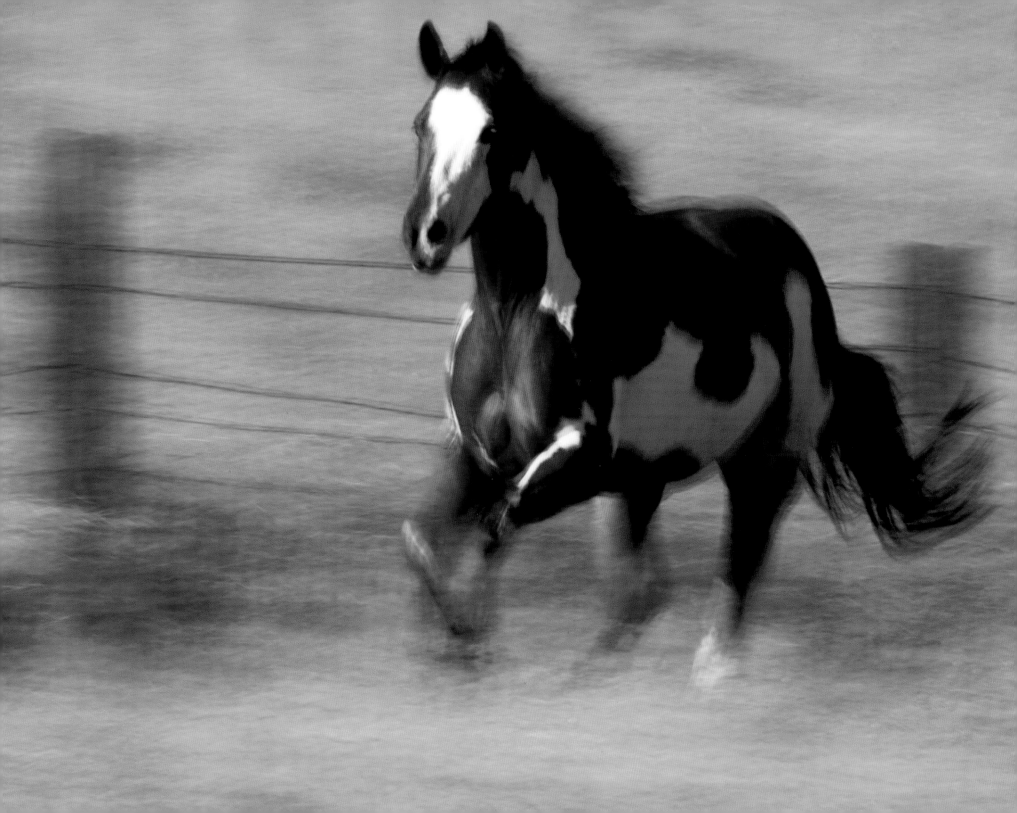

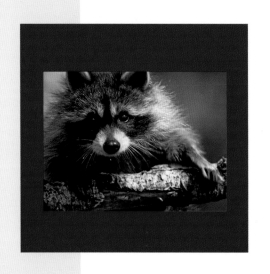

L ots of people talk to the animals...Not very many listen...That's the problem.

Bejamin Hoff, The Tao of Pooh

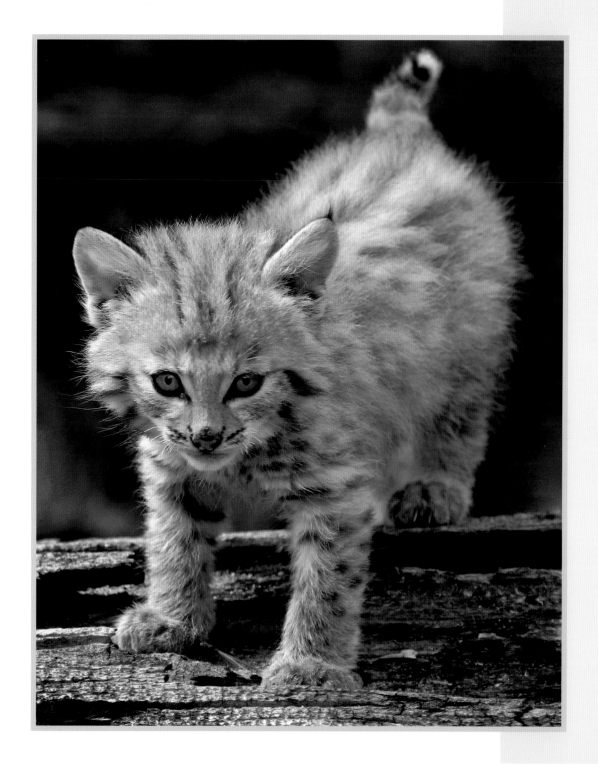

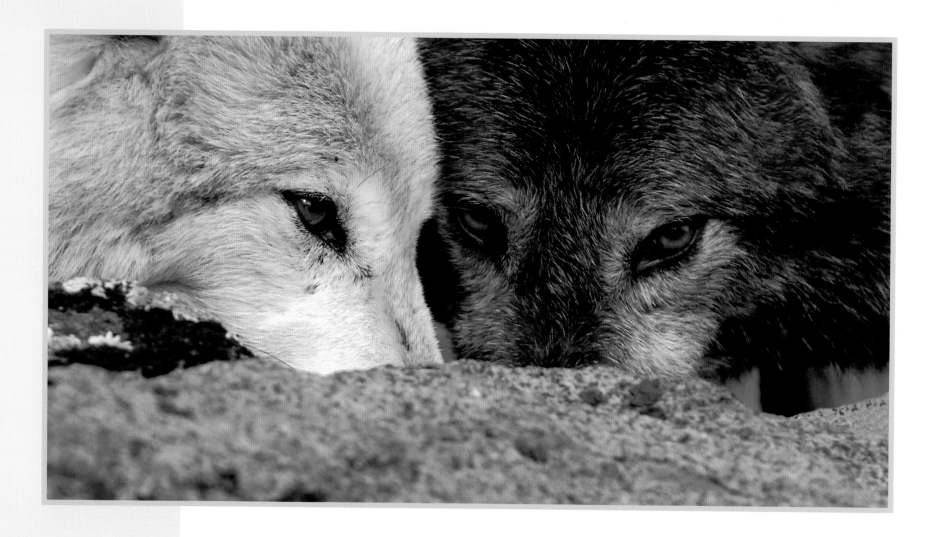

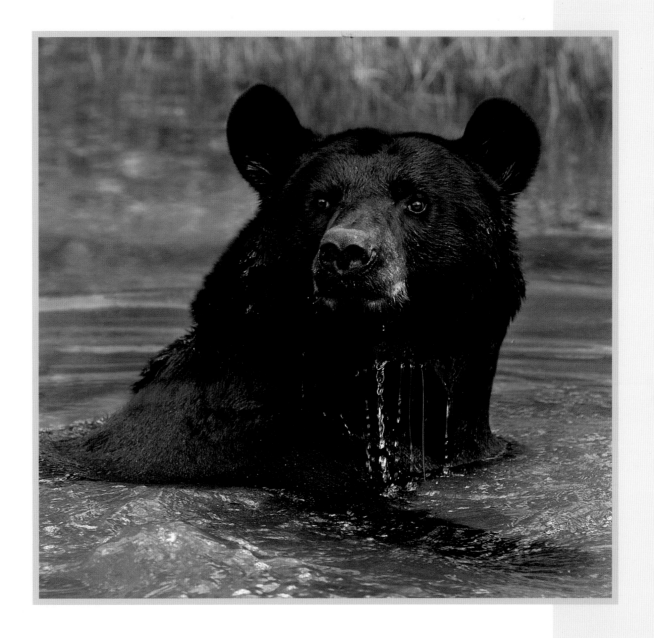

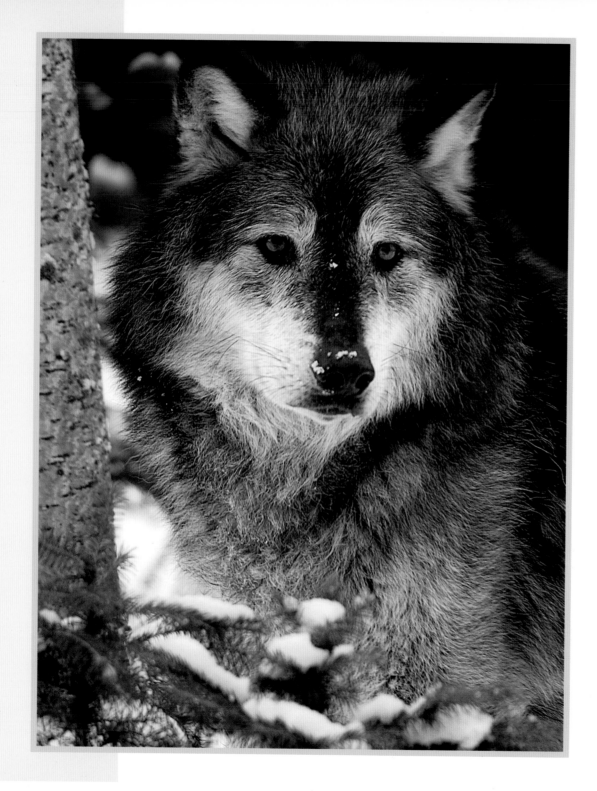

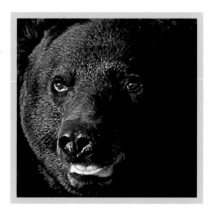

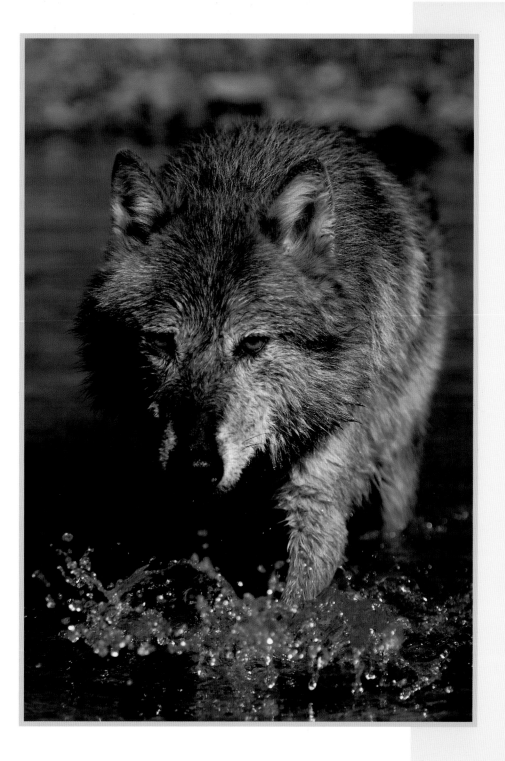

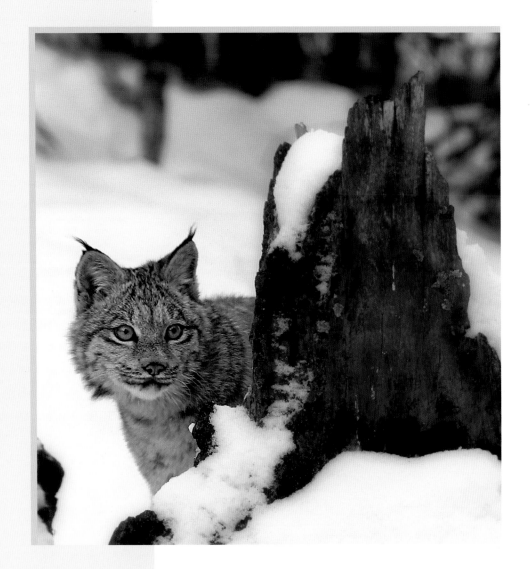

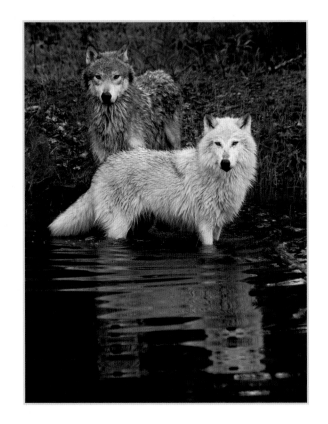

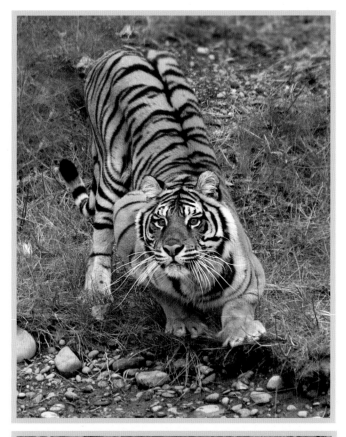

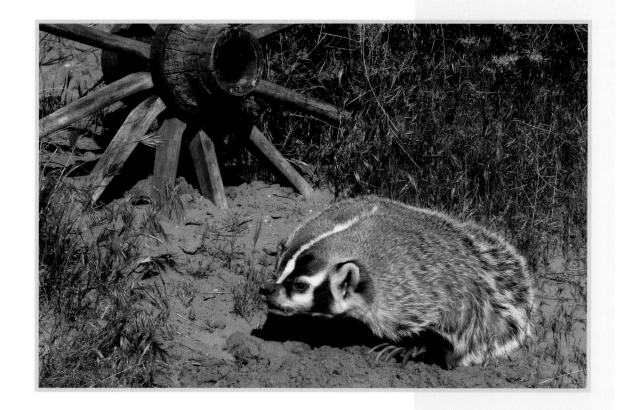

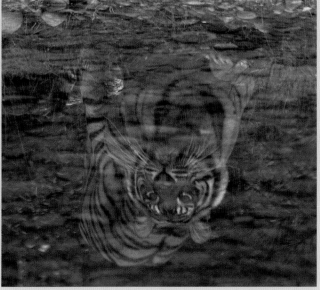

KIMI LUCAS

Kimi Lucas has more than 15 years of experience creating compelling images that reflect her love of color, strong graphics, and the natural environment.

A photo workshop at Triple "D" was a defining moment that spurred Kimi to pursue a career as a wildlife and nature photographer. She has studied with David Middleton and the Olympic Mountain School of Photography.

A passion for the environment has led Kimi to mix her love of the outdoors with photography. She also teaches, and it has become one of her favorite ways to share her joy of photography.

Kimi's work has been presented in exhibits at the University of Idaho's Visitor Center and the 2005 Moscow (Idaho) Artwalk.

BRAD MCPHEE

Brad McPhee is a dedicated photographer with more than 25 years of experience. Brad's first career was dentistry. His new vocation is wildlife photography.

Brad has taught intraoral (macro) digital and film photography extensively in the United States and Canada. He has published articles in Concepts magazine about digital intraoral photography.

Brad mixes his love of photography with a passion for giving. He has founded a company called CharityPhotos.com that allows non-profit organizations to use his photos to raise money.

His Tacoma, Wash., clients include Point Defiance Zoo and Aquarium, multiple private and public schools, Chambers Creek Guild, and the Pierce County Dental Society.

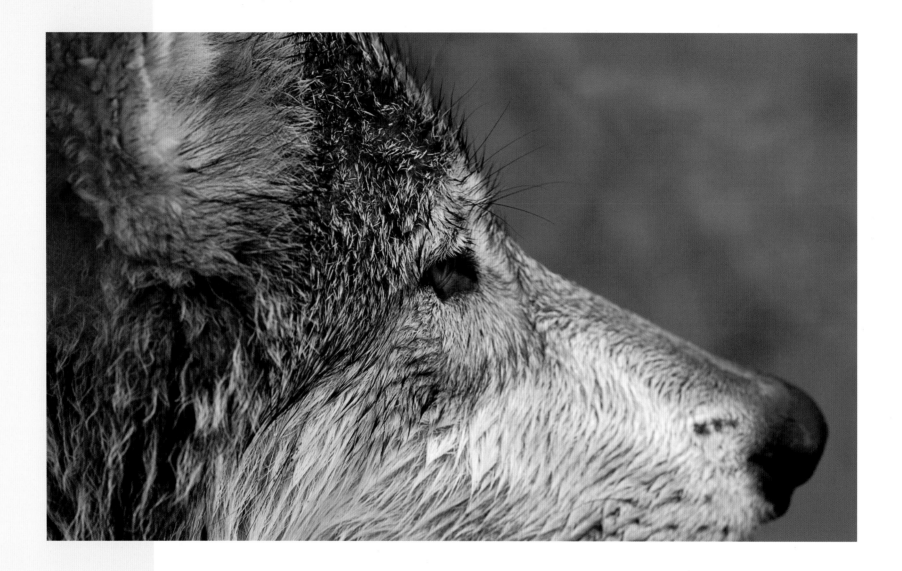

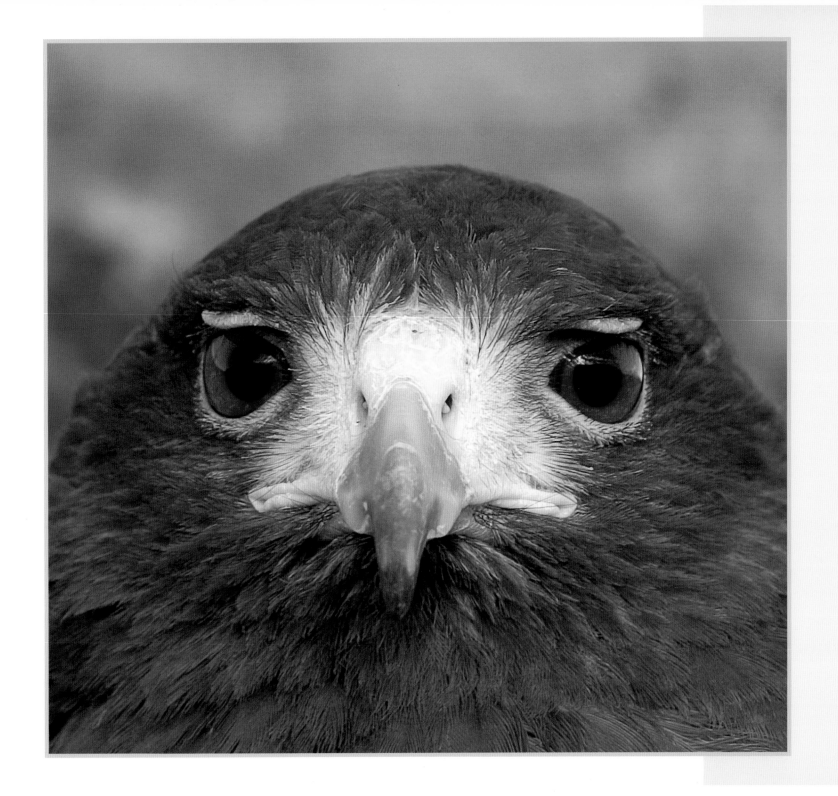

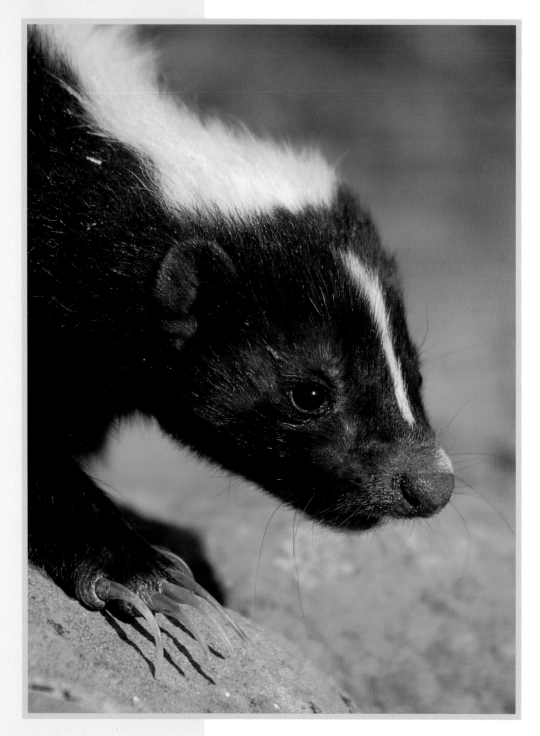

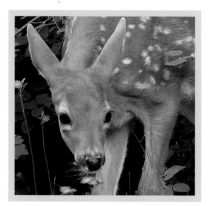

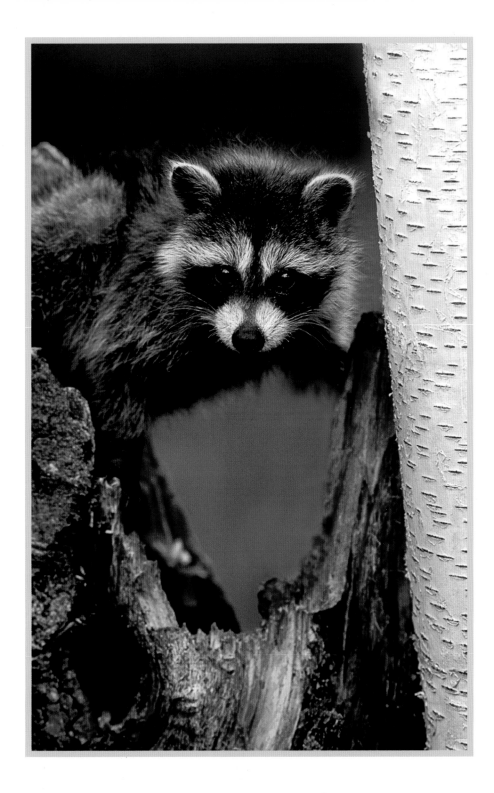

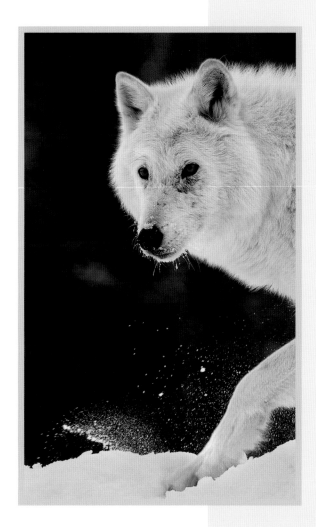

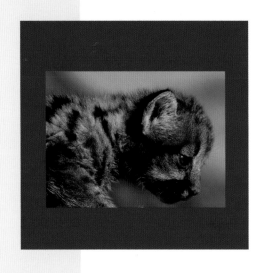

Anyone who has accustomed himself to regard the life of any living creature as worthless is in danger of arriving also at the idea of worthless human lives.

Dr. Albert Schweitzer

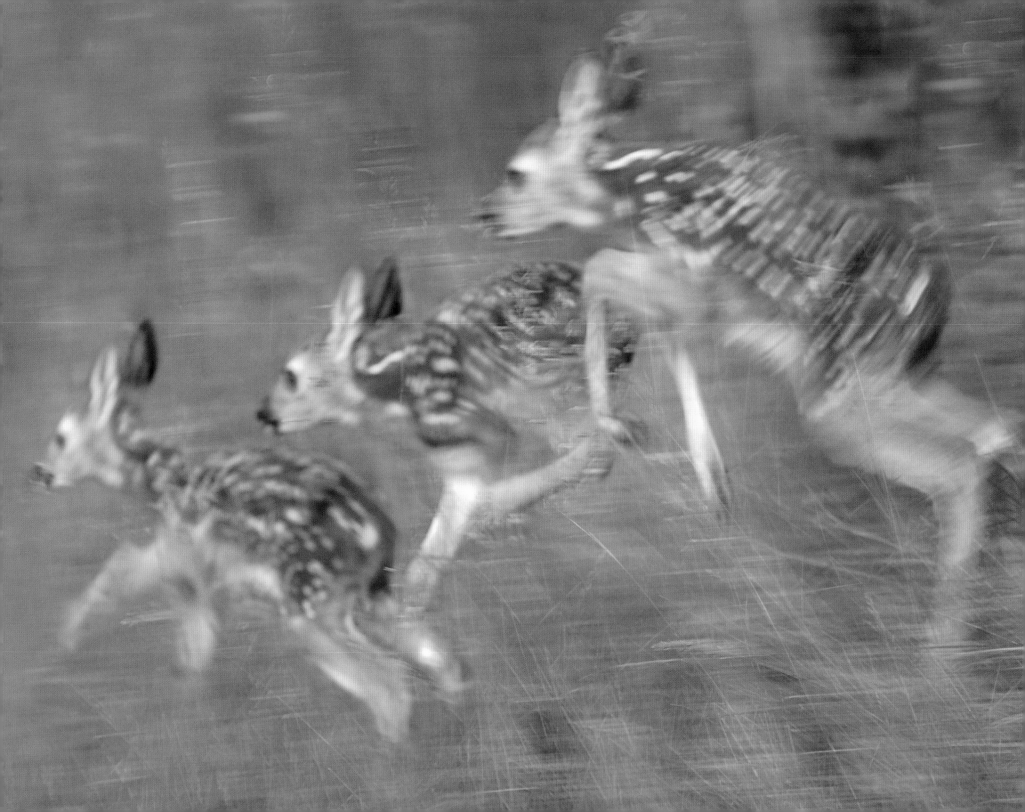

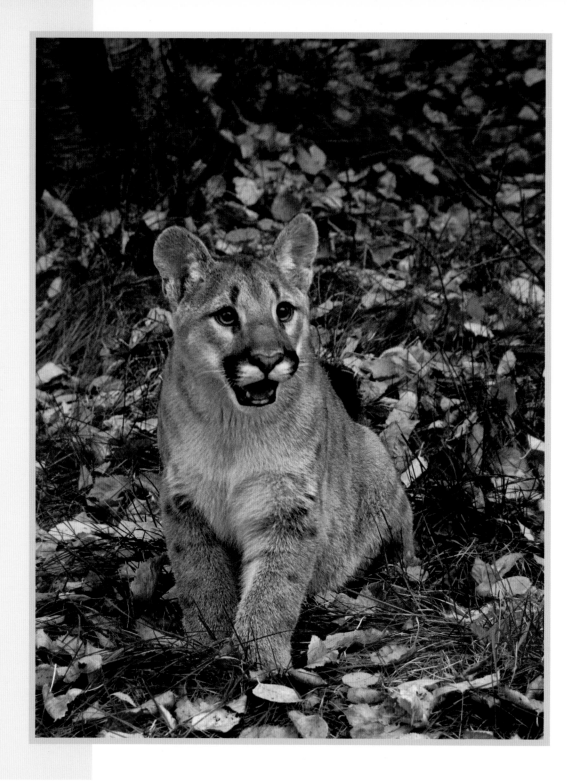

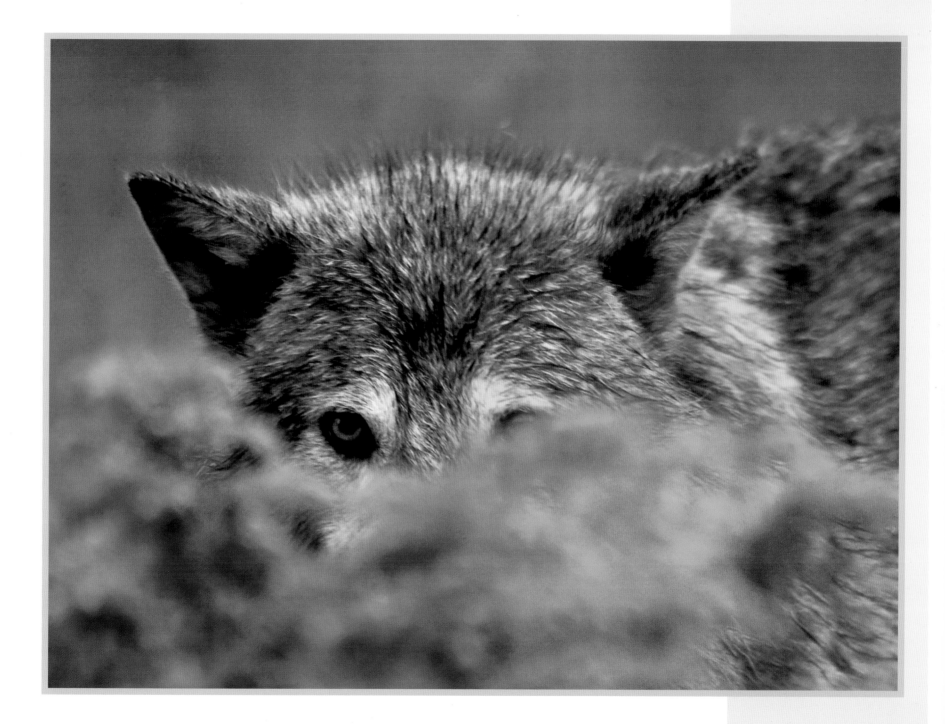

PATRICK REEVES

Patrick Reeves quit a dead-end job in 2003 and began traveling around the country to study photography with some of the country's leading photo educators. His love of the outdoors and nature led him to pursue outdoor and wildlife photography.

With a degree in adventure education and special programs, Patrick has used his knowledge of the outdoors to work as a wilderness instructor, adventure therapist, professional ski patroller, and now a wildlife and outdoor photographer.

His photos have appeared in numerous publications, and he has a permanent show at his downtown Bellingham, Wash., gallery.

Patrick now devotes himself full-time to photography, traveling, studying, teaching, and chasing the light.

CAROLYN E. WRIGHT

Carolyn Wright is an attorney specializing in the legal needs of photographers and a pro shooter with an active nature and wildlife photography business. Her award-winning images have been used in books, magazines and corporate marketing materials.

Carolyn is particularly tuned to the special interests of women in photography. She teaches women-only wildlife workshops and is a charter member of Women in Photography International.

She has more than 20 years of general business experience, as well as an MBA and a Juris Doctor (JD). This knowledge, combined with her training and experience teaching at all levels from grade school to graduate school, provides a strong foundation to help others, and guides her photography career.

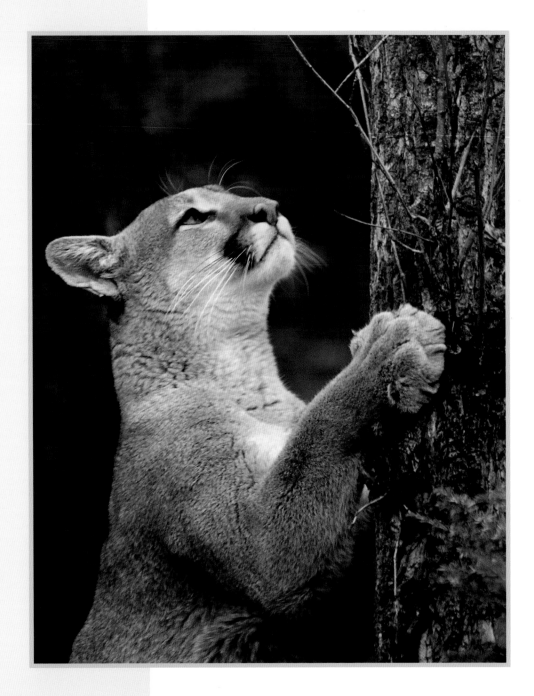

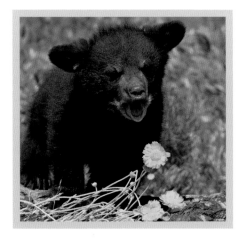

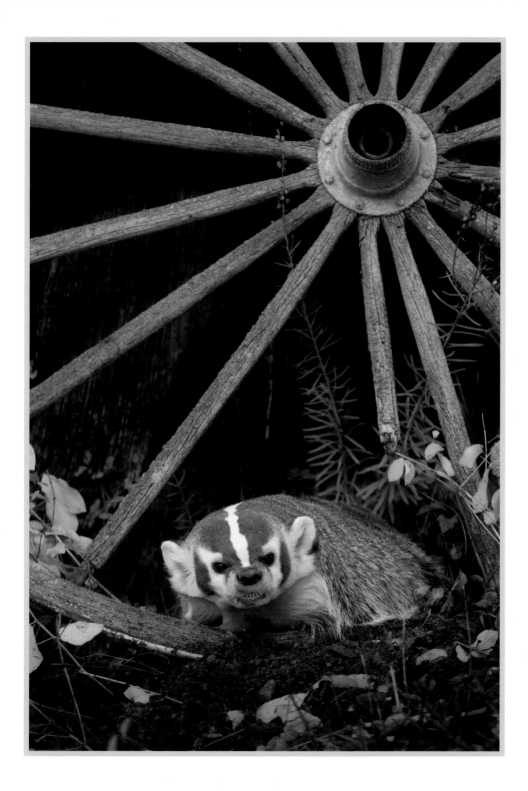

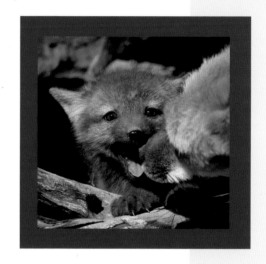

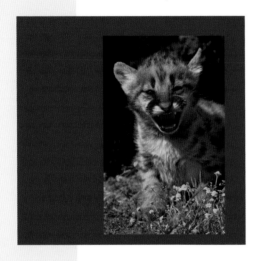

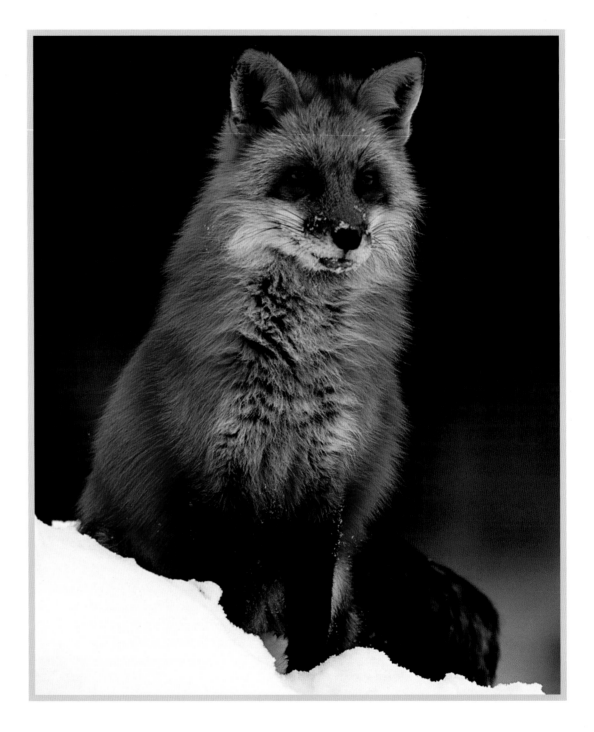

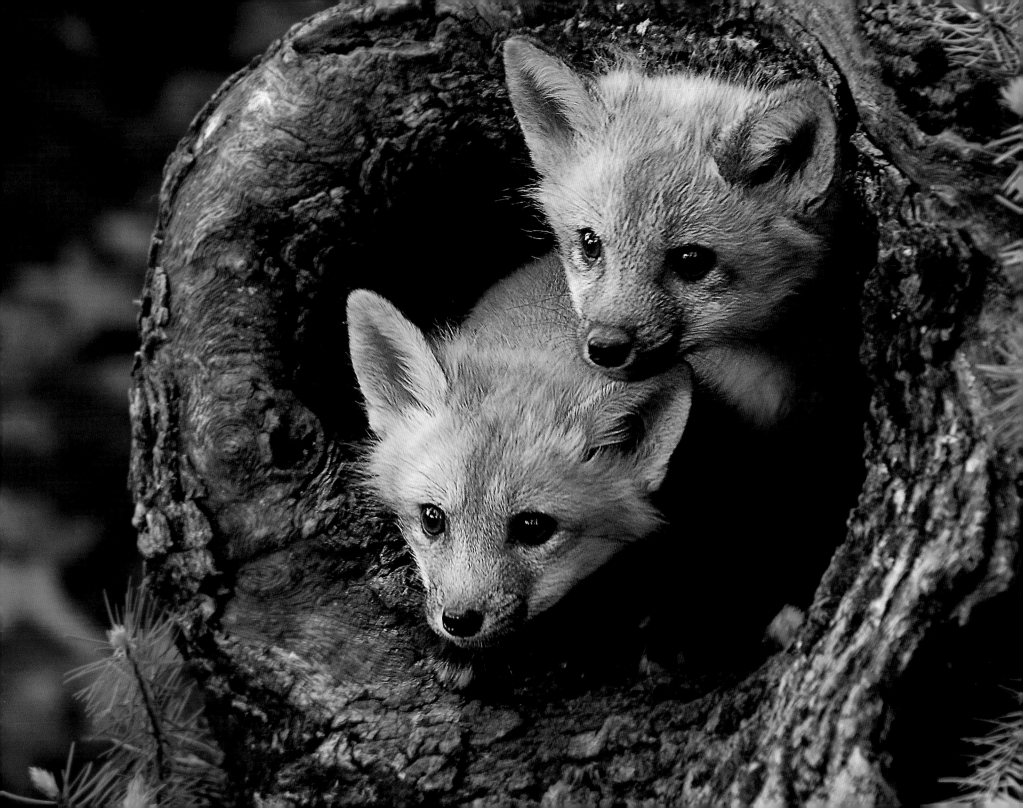

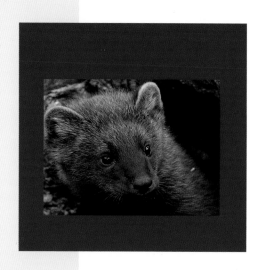

am sometimes asked why I spend so much of my time and money talking about kindness to animals when there is so much cruelty to men? I answer: "I am working at the roots."

George T. Angell

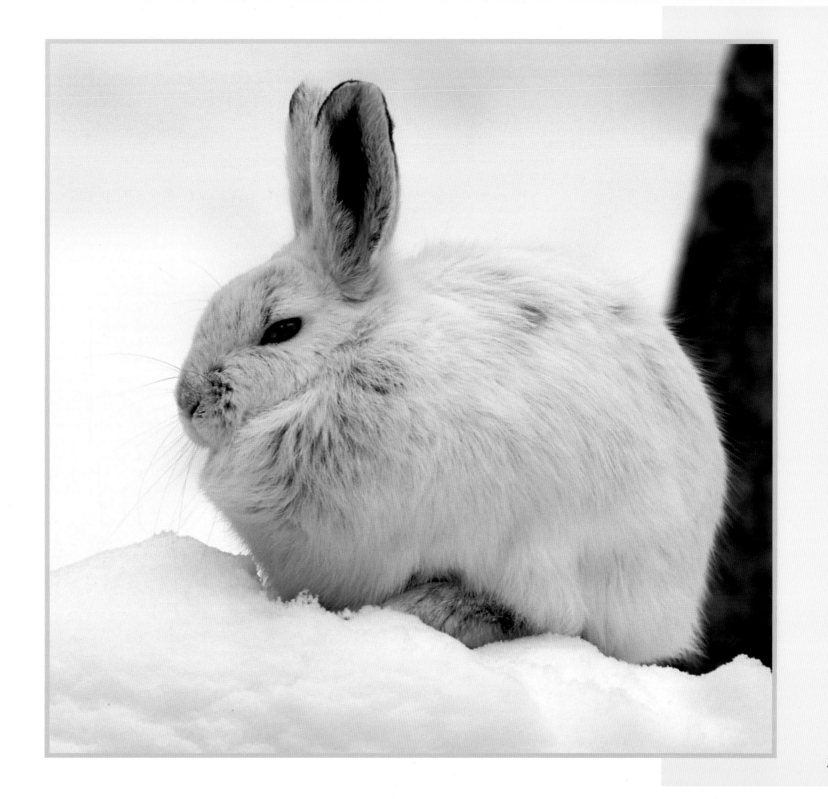

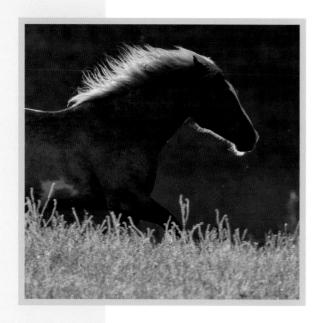

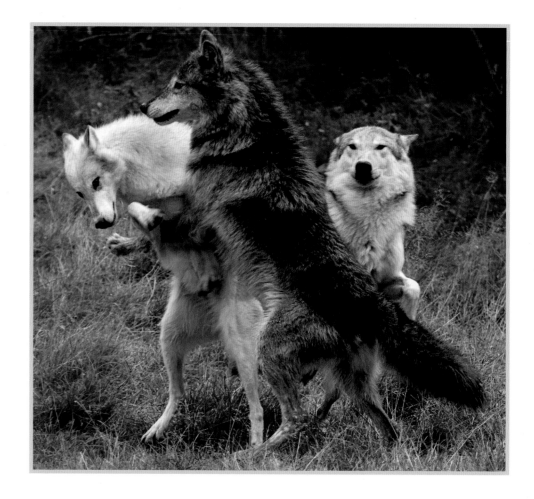

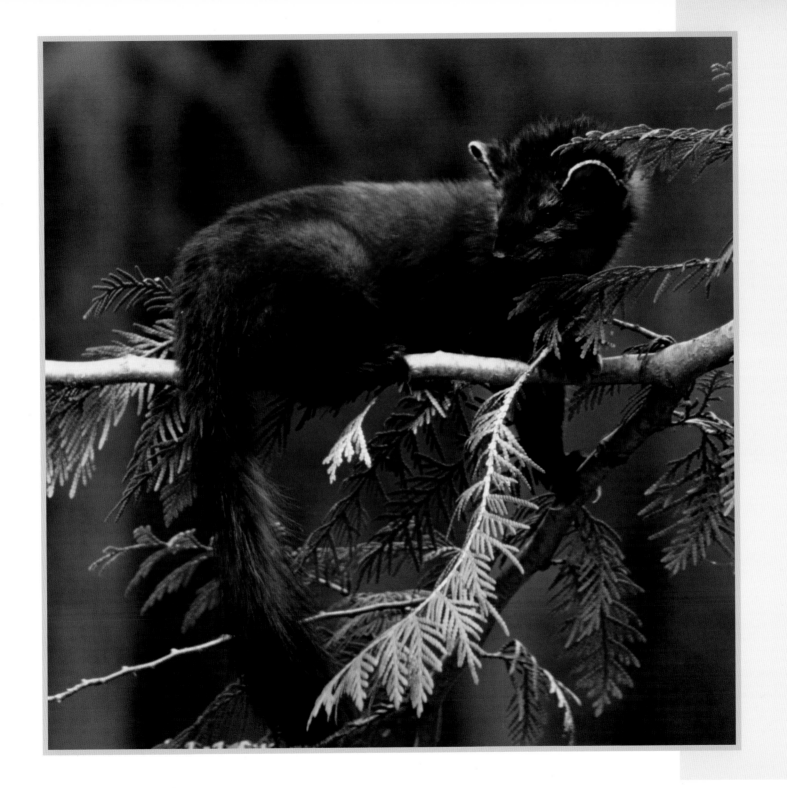

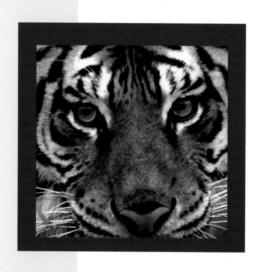

A country is known by the way it treats its animals.

Jawaharlal Nehru

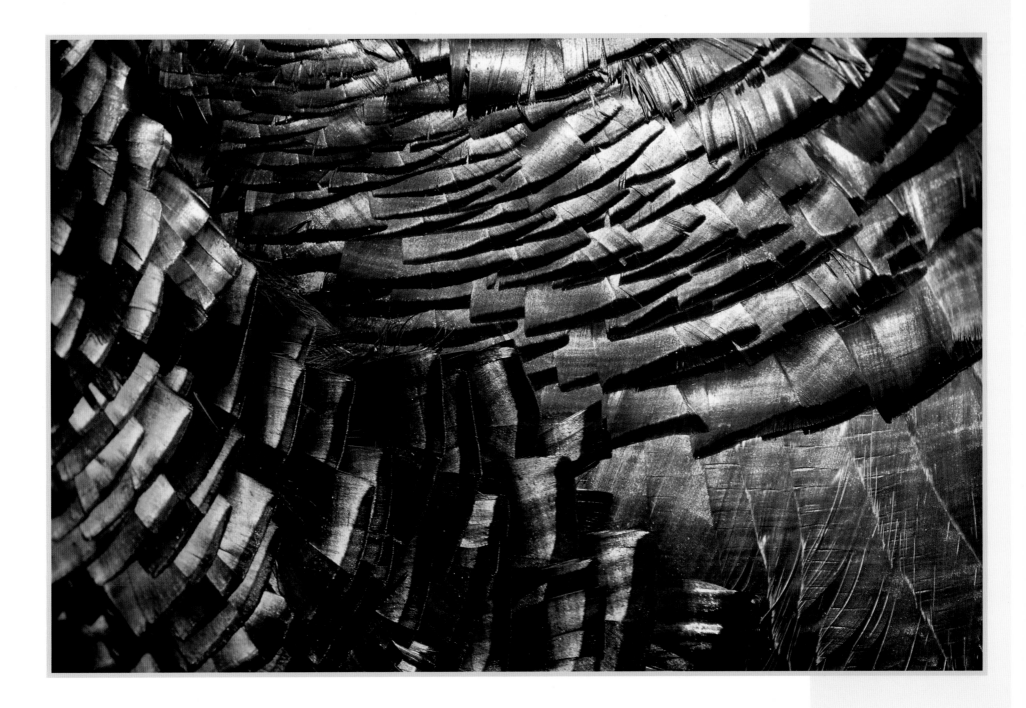

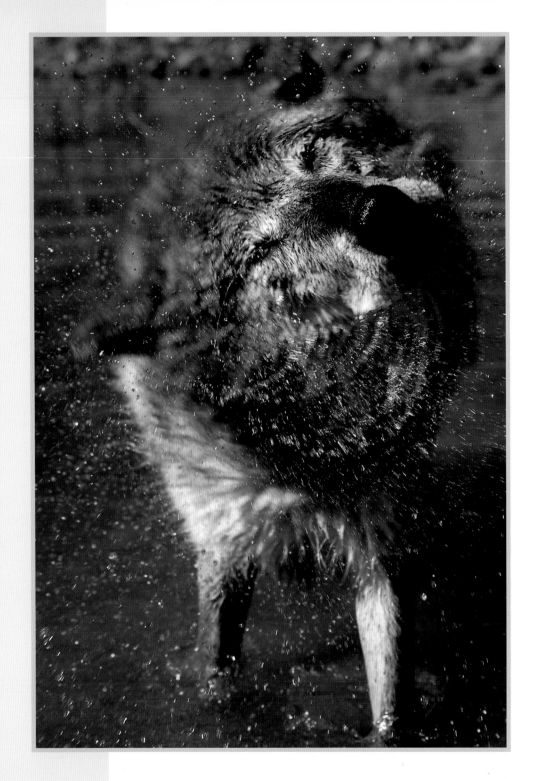

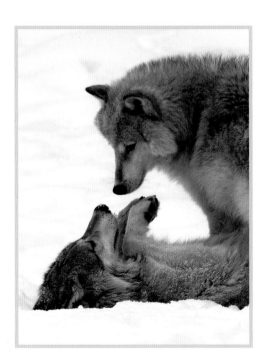

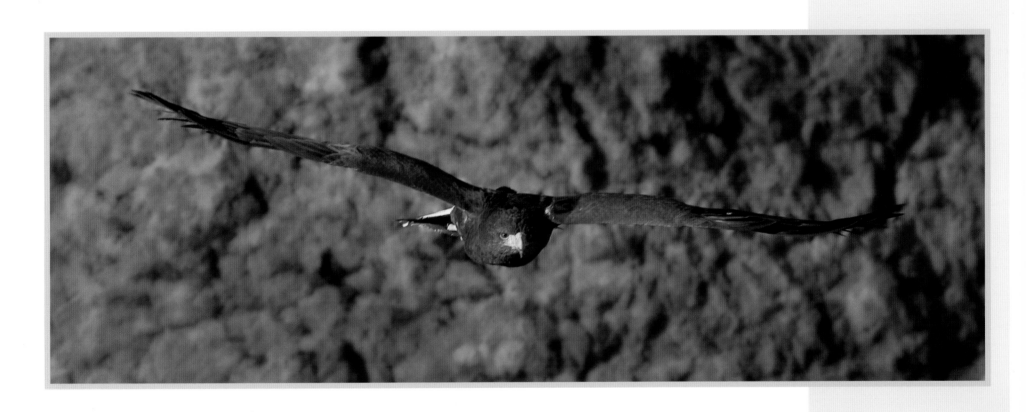

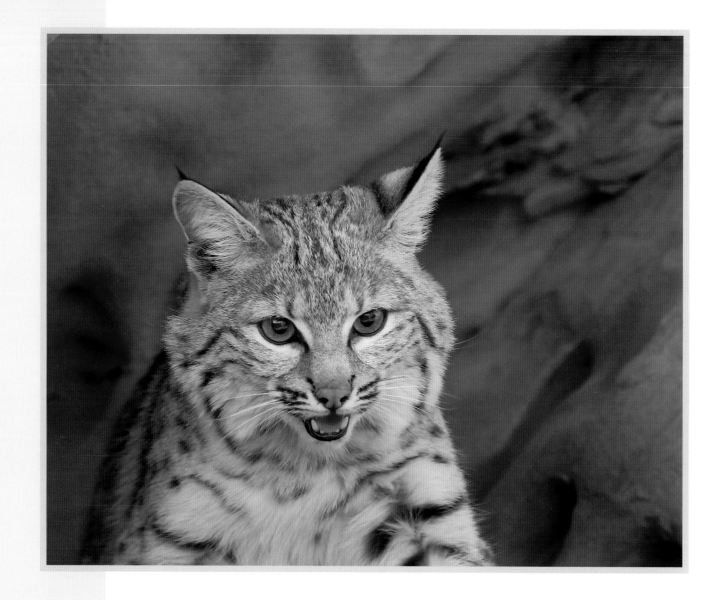

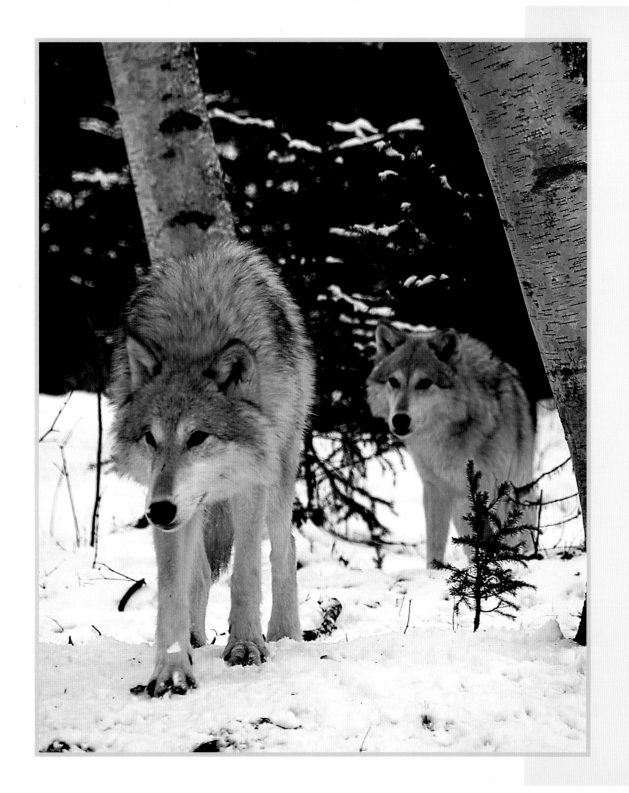

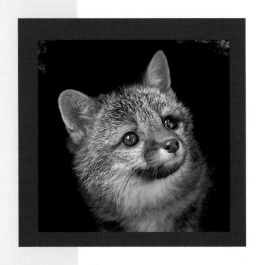

W

hat has been called the "Golden Rule" should be enlarged from the area of mere mankind to that of the whole animal kingdom.

Thomas Hardy

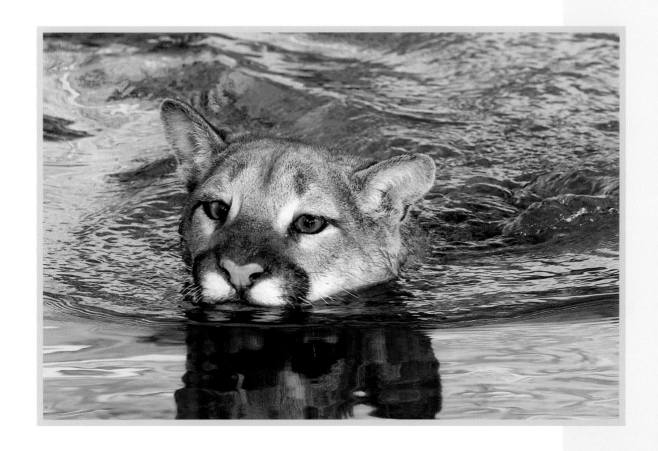

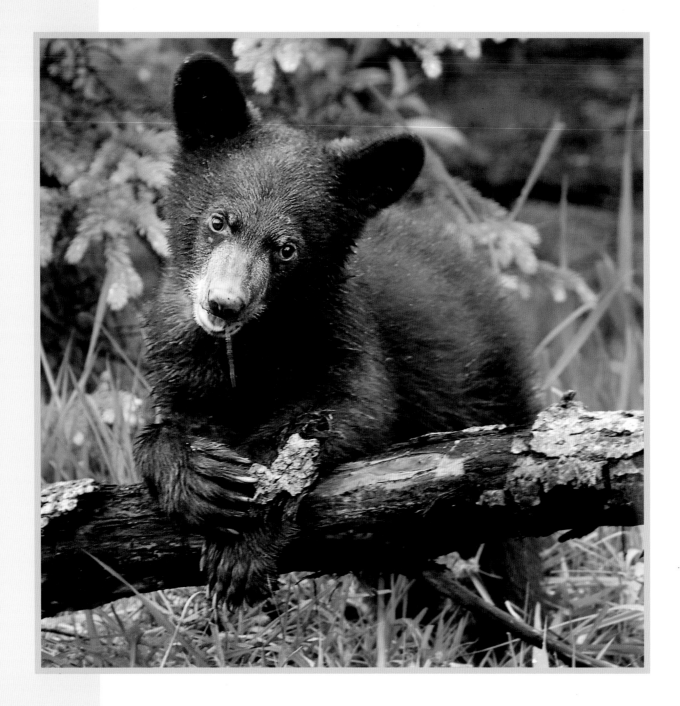

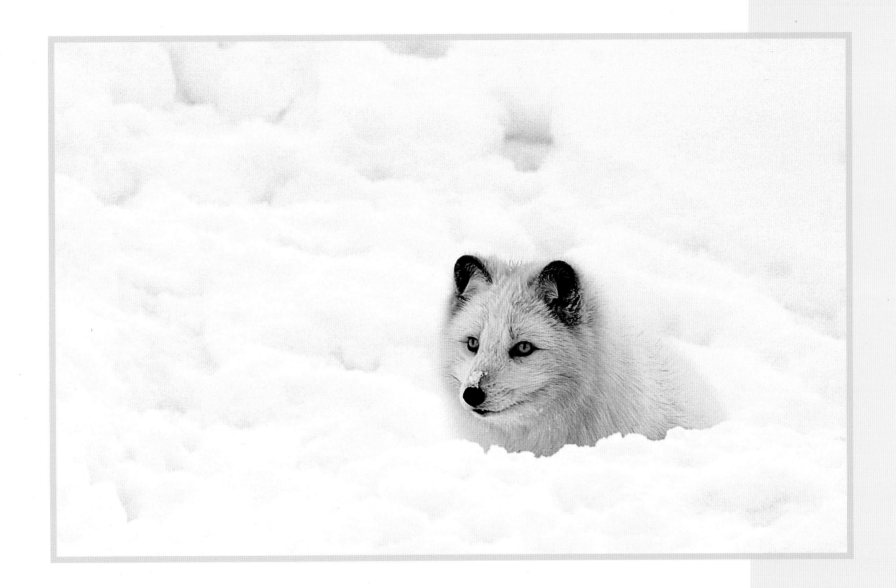

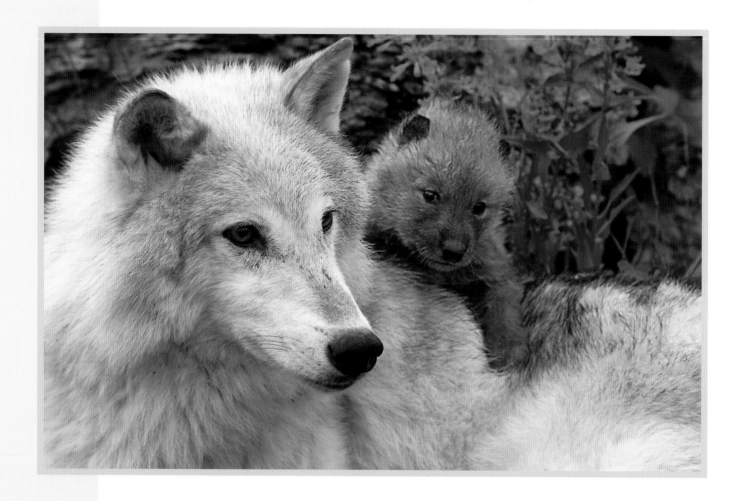

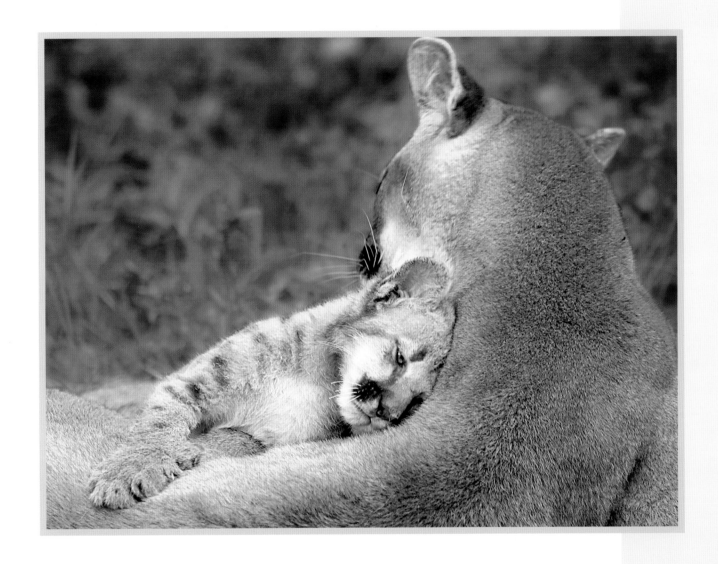

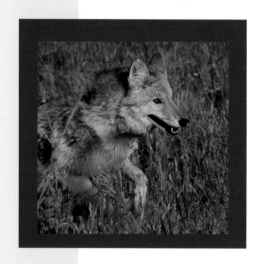

If all the beasts were gone, men would die from a great loneliness of spirit, for whatever happens to the beasts also happens to the man.

Chief Seattle

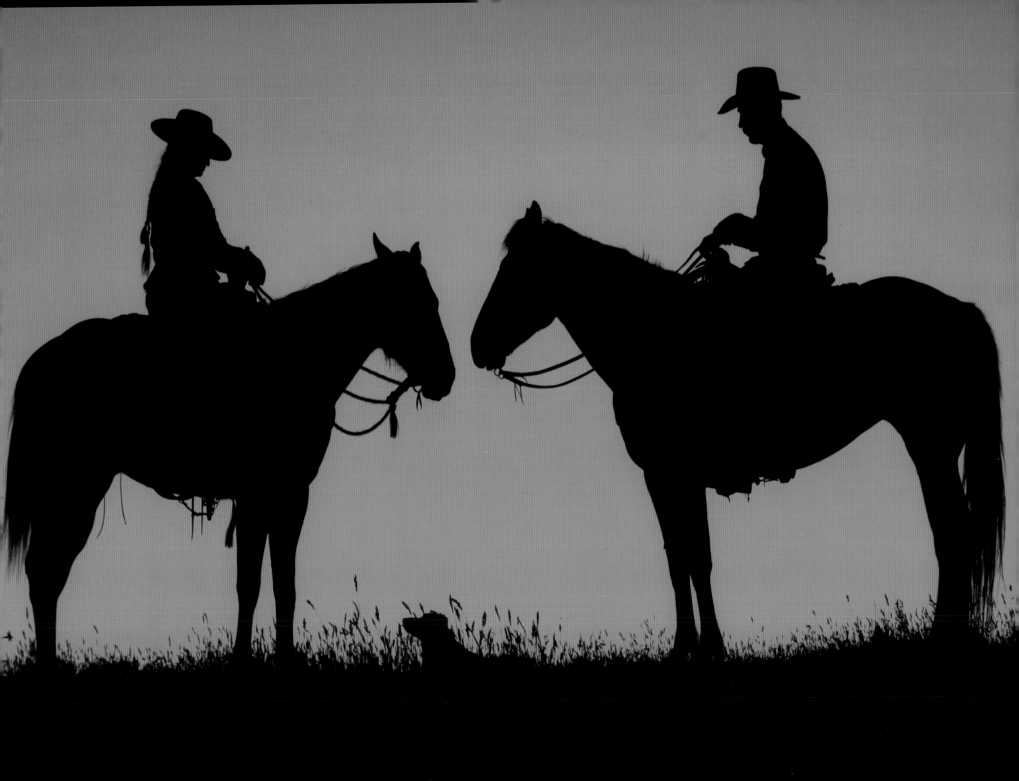

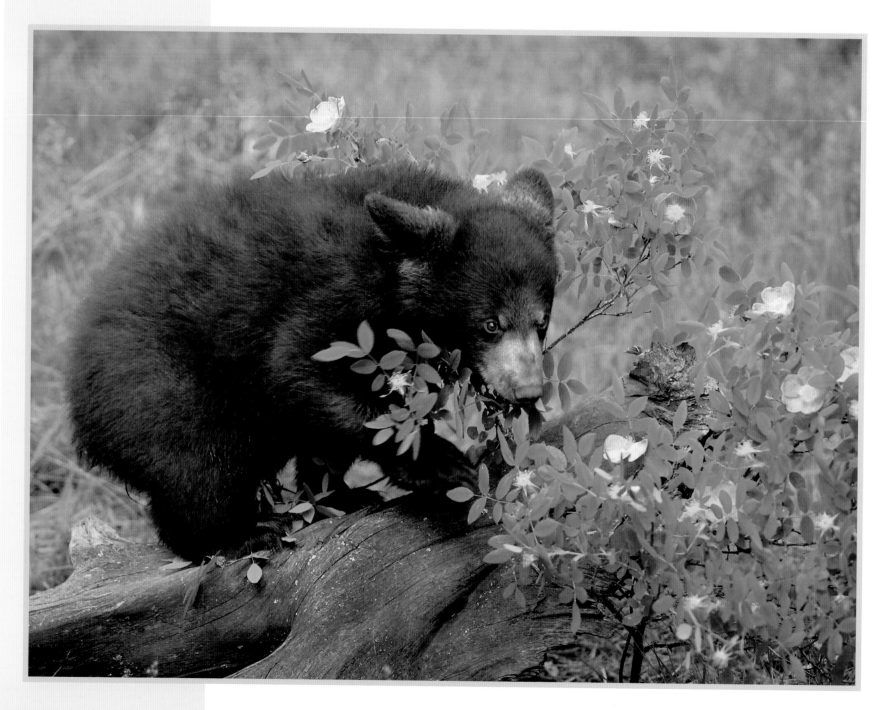

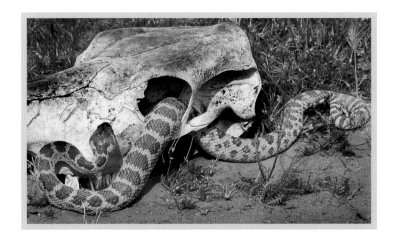

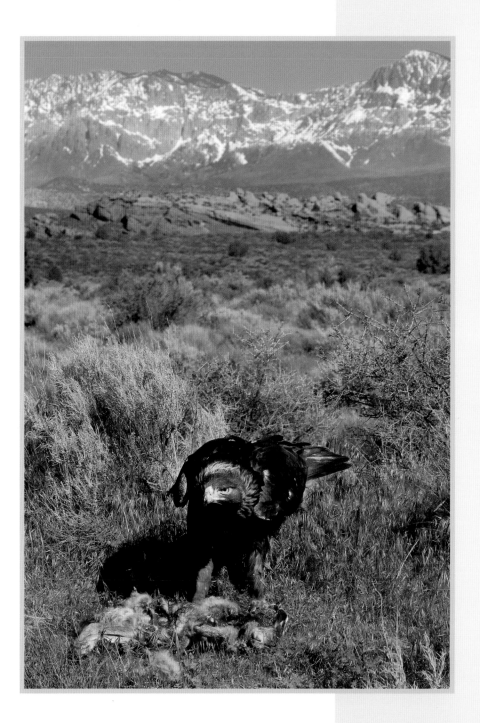

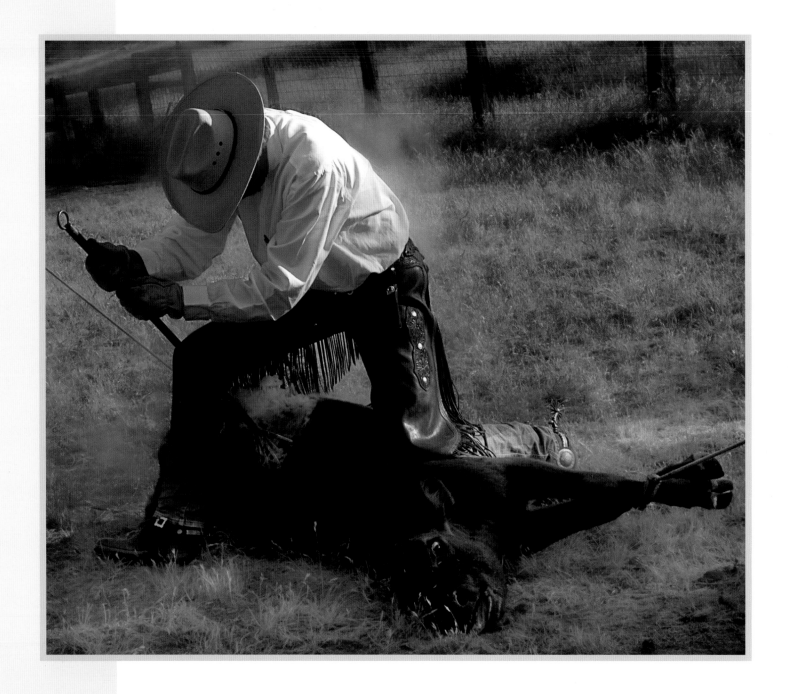

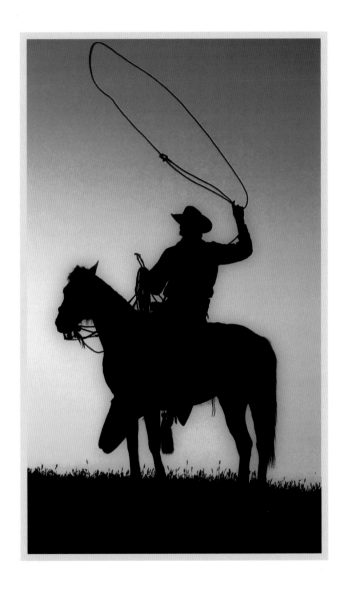

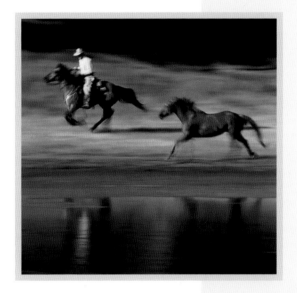

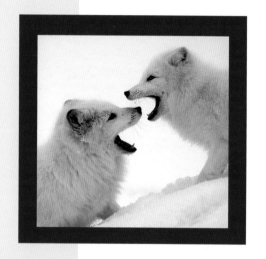

When one tugs at a single thing in nature, he finds that it is attached to the rest of the world.

John Muir

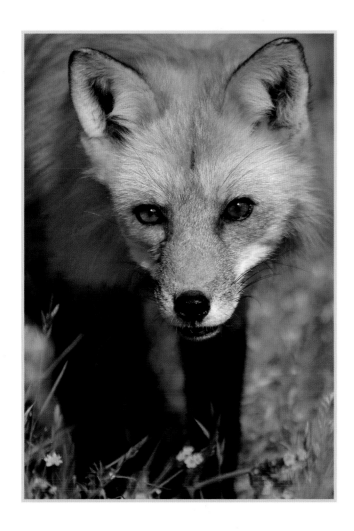
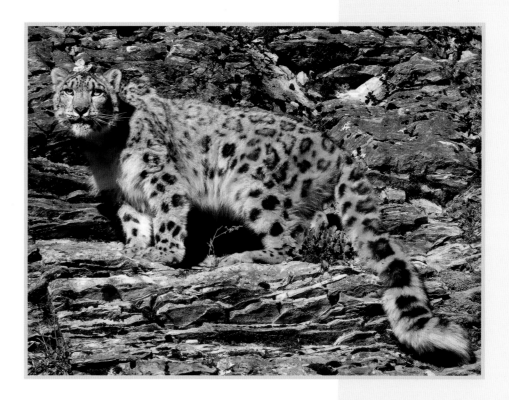

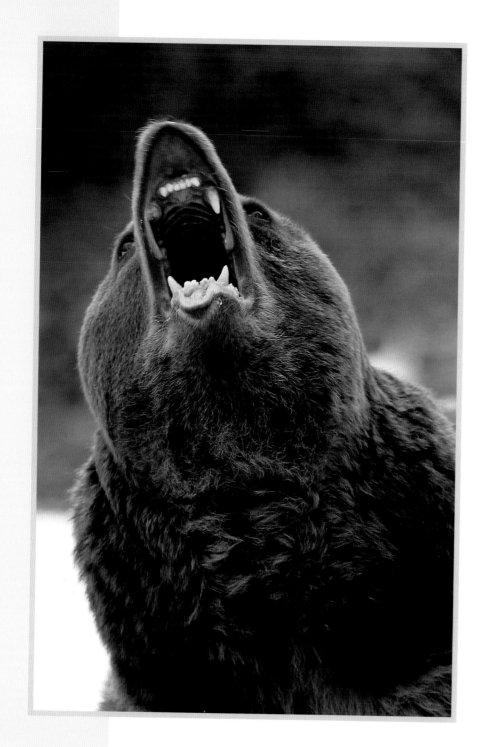

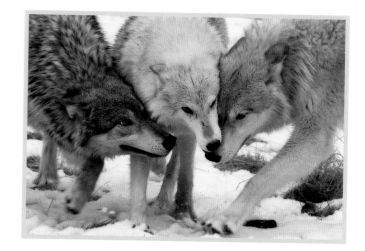

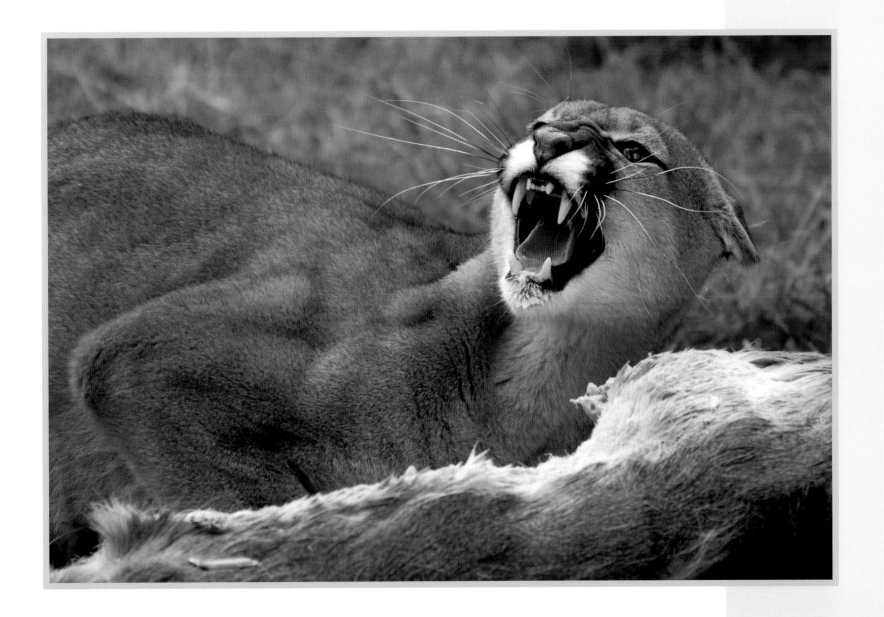

Triple D foreman Rick Meyer

The Triple "D" Game Farm started in 1972 with a single, simple purpose – to propagate wild animal species common to the Northwest. Triple "D" grew from a family's love and concern for wildlife. Lorney Deist, a game warden for the State of Montana, inspired and taught his son, Jay, about animal behavior and how to care for and handle orphaned and injured wild animals.

In 1975, a movie company contacted Triple "D" to use its animals as models for a movie about wolverines. Triple "D" was one of the first game farms to provide trained animals for the motion picture and still photography industries.

Triple "D" is home to a variety of animal species that can be photographed in several large natural settings. Photographers work with experienced and caring animal handlers in professionally designed enclosures. Typically, the photography takes place with no fence between photographers and animals. Because the animals are in their natural environment at Triple "D," they exhibit a variety of instinctual behaviors, offering incomparable photographic opportunities.

Triple "D's" experienced staff is led by foreman Rick Meyer, also known as "The Bear." Rick, a Montana native, has been with Triple "D" for more than a decade. Rick's dedication and love for the animals he handles is evident during every photo session. From BJ the bear to the smallest of creatures, Rick's intuitive knowledge of animal behavior provides spectacular wildlife viewing opportunities.

Triple "D" prides itself on the care and health of its animals. Preservation of endangered species is a priority so that future generations may enjoy them. Triple "D" also maintains an active educational program by inviting groups to visit the game farm. Jay and Kim want everyone, especially children, to develop an appreciation for these wild creatures. The Deists hope that this educational process will motivate others to work to protect endangered wildlife and their habitat.

Since that first movie more than 25 years ago, Triple "D" has served a multitude of professional and amateur still photographers and movie companies. Its clientele includes many of the most published and well-known wildlife photographers in the world, including film crews from National Geographic, Nature, Disney, BBC and other cinema productions.

Triple "D" is now owned and operated by Jay and his wife Kim Deist. Like Jay, Kim has always had a love for animals. She now helps care for the young and other animals that have special needs. When they aren't traveling or working with their business, the Deists enjoy the scenic beauty of Montana and its wilderness areas.

This book would not have been possible without the contribution of the Deists and the Triple "D" crew. Their devotion to wildlife made it possible for the photographers featured in this book to gain access to the animals.

If you are interested in visiting the Triple "D" Game Farm, contact the Olympic Mountain School of Photography at www.cameraclass.com or visit the Triple "D" website at www.tripledgamefarm.com.

Triple D Game Farm owner Jay Deist

PHOTOGRAPHER CONTACTS

Authors
 Scott Bourne www.wildlifeshooter.com
 David Middleton www.davidmiddletonphoto.com

Emerging Pros
 Richard Badger rrbadger@aol.com
 Carlene Cunningham jc@elite.net
 Jim Cunningham jc@elite.net
 Victoria Dye www.victoriasimages.com
 Debra Feinman www.debrafeinman.com
 Donald Knight www.naturephotographer.us
 Kimi Lucas www.kimilucas.com
 Brad McPhee www.charityphotos.com
 Patrick Reeves www.prphotography.us
 Carolyn Wright www.vividwildlife.com

PHOTO CREDITS

Page-2	Scott Bourne	Page-41	Carolyn Wright
Page-3	Scott Bourne	Page-42	Kimi Lucas
Page-4	Donald Knight	Page-43	Victoria Dye
Page-5	Donald Knight	Page-44	Patrick Reeves
Page-6	Scott Bourne	Page-45	Carolyn Wright
Page-7	Patrick Reeves	Page-46	Richard Badger
Page-8	Brad McPhee	Page-47	Kimi Lucas
Page-9	Patrick Reeves	Page-48	Debra Feinman
Page-10	Patrick Reeves	Page-49	Donald Knight
Page-11	Carolyn Wright	Page-50	Kimi Lucas
Page-12	David Middleton	Page-51	(L) Donald Knight (Rt) Patrick Reeves
Page-13	Scott Bourne	Page-52	(L) Richard Badger (Rt) Brad McPhee
Page-14	Scott Bourne	Page-53	(L) Brad McPhee (Rt) Carlene Cunningham
Page-15	(L) Patrick Reeves (Rt) David Middleton	Page-54	Scott Bourne
Page-16	Patrick Reeves	Page-55	Scott Bourne
Page-17	Debra Feinman	Page-56	Patrick Reeves
Page-18	Scott Bourne	Page-57	Scott Bourne
Page-19	Carlene Cunningham	Page-58	(L) Carolyn Wright (Rt) Donald Knight
Page-20	Scott Bourne	Page-59	(L) David Middleton (Rt) Scott Bourne
Page-21	Kimi Lucas	Page-60	Carolyn E. Wright
Page-22	(L) Scott Bourne (Rt) David Middleton	Page-61	Patrick Reeves
Page-23	(L) Donald Knight (Rt) Scott Bourne	Page-62	Carlene Cunningham
Page-24	Scott Bourne	Page-63	Brad McPhee
Page-25	Jim Cunningham	Page-64	Scott Bourne
Page-26	Brad McPhee	Page-65	Scott Bourne
Page-27	David Middleton	Page-66	(L) Debra Feinman (Rt) Patrick Reeves
Page-28	(L) Richard Badger (Rt) Donald Knight	Page-67	(L) Carolyn Wright (Rt) Carolyn Wright
Page-29	Scott Bourne	Page-68	(L) Carolyn Wright (Rt) David Middleton
Page-30	Donald Knight	Page-69	Brad McPhee
Page-31	Donald Knight	Page-70	Patrick Reeves
Page-32	Scott Bourne	Page-71	David Middleton
Page-33	(L) Kimi Lucas (Rt) Scott Bourne	Page-72	(L) Patrick Reeves (Rt) Debra Feinman
Page-34	(L) Donald Knight (Rt) Jim Cunningham	Page-73	David Middleton
Page-35	(L) Carlene Cunningham (Rt) Scott Bourne	Page-74	Debra Feinman
Page-36	Jim Cunningham	Page-75	David Middleton
Page-37	Victoria Dye	Page-76	(L) Debra Feinman (Rt) Carolyn Wright
Page-38	Jim Cunningham	Page-77	Scott Bourne
Page-39	(L) Richard Badger (Rt) Victoria Dye	Page-78	Jim Cunningham
Page-40	(L) David Middleton (Rt) Kimi Lucas	Page-79	Donald Knight

PHOTO CREDITS

Page-80	Richard Badger
Page-81	Richard Badger
Page-82	Victoria Dye
Page-83	Richard Badger
Page-84	Victoria Dye
Page-85	Richard Badger
Page-86	Carolyn Wright
Page-87	Scott Bourne
Page-88	Scott Bourne
Page-89	(L) Jim Cunningham (Rt) Jim Cunningham
Page-90	Carolyn Wright
Page-91	(L) Carolyn Wright (Rt) Carolyn Wright
Page-92	Scott Bourne
Page-93	(L) Carolyn Wright (Rt) Donald Knight
Page-94	(L) Donald Knight (Rt) Scott Bourne
Page-95	Scott Bourne
Page-96	Scott Bourne
Page-97	Scott Bourne

BOOK ORDER FORM

Would you like additional copies of this book? If so, please use this order form. Please send the form with your payment to:

*(PLEASE MAKE CHECKS or MONEY ORDERS TO **OMSP**)*

Olympic Mountain School Press
P.O. Box 1114
Gig Harbor, WA 98335

Please send me _____ copy(s) of the book: *Captivating Wildlife - Images from America's top ten emerging wildlife photographers.*

Price: $29.95 - U.S. funds. Includes tax and shipping to the USA. Please fill in your contact information below. *Please print clearly.*

NAME: _____

ADDRESS: _____

CITY/STATE/ZIP: _____

TELEPHONE: _____

E-MAIL ADDRESS: _____

(Sorry USA residents only please)